The Utah Photographs of G. E. Anderson

The Utah Photographs

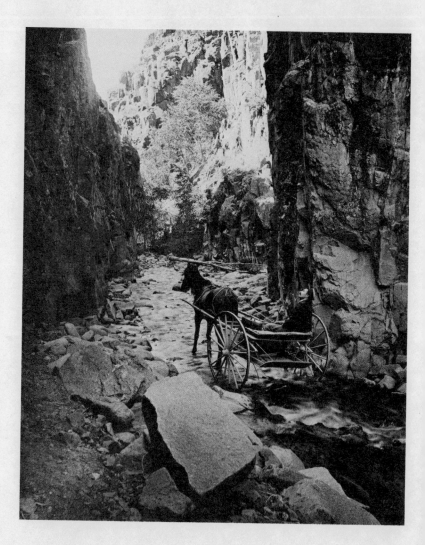

of George Edward Anderson

BY RELL G. FRANCIS

FOR THE

AMON CARTER MUSEUM

OF WESTERN ART,

FORT WORTH, TEXAS

University of Nebraska Press: *Lincoln and London*

Library of Congress Cataloging in Publication Data

Anderson, George Edward, 1860–1928.
 The Utah photographs of George Edward Anderson.

 Includes bibliographical references and index. 1. Photography, Artis-
tic—Exhibitions. 2. Utah—Description and travel—Views. 3. An-
derson, George Edward, 1860–1928. I. Francis, Rell G., 1928–
II. Amon Carter Museum of Western Art, Fort Worth, Tex. III. Title.
TR646.U6F672 1979 779′.9′9792 79-1123
ISBN 0-8032-1952-0

The Amon Carter Museum was established in 1961 under the will
of the late Amon G. Carter for the study and documentation of
westering North America. The program of the museum, expressed
in publications, exhibitions, and permanent collections, reflects
many aspects of American culture, both historic and con-
temporary.

*Portions of the Introduction were published in different form
in the *American West*.

Contents

Illustrations

Illustration credits: plates 55, 67, and 98 courtesy of Brigham Young University Library; plate 39 courtesy of Historical Department, The Church of Jesus Christ of Latter-day Saints; plates 5, 35, 36, 37, 38, 40, 53, 57, 87, 95, 103, 104, 106, 112, and 114 courtesy of Robert Edwards Collection; all other photographs courtesy of Rell G. Francis.

Preface

IN 1972 I had never heard of George Edward Anderson, even though I had lived in his home town—Springville, Utah—for many years and had known his son and some of his associates very well. I had happened upon his work quite by chance when I was searching for photographs of Cyrus E. Dallin, a noted Springville sculptor, while I was writing his biography. A friend and local leader of the Church of Jesus Christ of Latter-day Saints (Mormon), Leo Crandall, told me he had some ten thousand Anderson glass-plate negatives that might include some of the pictures of Dallin I was looking for. Later, when Crandall gave me the entire collection, I was amazed to find pictures of Dallin as well as important historical subjects. I temporarily dropped my Dallin project and began sorting, cataloging, and printing the negatives that I felt had historical and artistic merit. Within a year I had produced an exhibit of more than one hundred and fifty brown-tone enlargements of Anderson's work; this exhibit was featured at the annual Mormon Arts Festival at Brigham Young University, Provo, Utah, in 1973. Exhibit visitors of all ages were fascinated with the remarkably clear images. Soon after, *Popular Photography* magazine published my article on Anderson and announced that "a fabulous collection of photographic Americana" had been discovered.[1] Consequently, many wanted to know more about George Edward Anderson.

I discovered that the Crandall collection had been microfilmed several years earlier by the historical department of the Church of Jesus Christ of Latter-day Saints in Salt Lake City, Utah, and several of Anderson's church subjects had frequently been published in Latter-day Saint (LDS) periodicals and books. Strangely, Anderson's name could not be found in the LDS *Journal History, Church Chronology,* or *Pioneers and Prominent Men of Utah.* Somehow this man and his lifetime of dedication and determination had been neglected.

Perhaps nothing is as intriguing in the Anderson story as the strange history of the glass-plate negatives. Without them, and the extensive Anderson diaries, I could not, of course, have prepared this work. Within months of Anderson's death in 1928 two of his friends, John F. Bennett and Junius E. Wells, negotiated with Anderson's widow to purchase the bulk of his negatives—now estimated at over thirty thousand—for twenty-five hundred dollars for the LDS church.[2] In a letter to Joseph Fielding Smith, then LDS church historian, Junius Wells described the value of the collection and the impact of Anderson.

That there are in this collection negatives of Church scenes, groups of historic gatherings, views of notable celebrations, parades and pageants, of almost inestimable interest and value to the Historian's Office, I believe you already realize. . . . That George Ed Anderson performed a very remarkable mission while traversing the scenes of the Church History—the missions at the East and abroad, visiting hundreds of homes and neighborhoods where he bore a faithful testimony of the Truth and made countless friends for the Church, I personally know; and that he did so without adequate recompense in poverty at times to the distress of his family. The increment of his life's work should now come to them.[3]

The bulky glass plates, of various sizes up to 14 by 17 inches, weighing between three and four tons en masse, found limited use in the crowded archives at the LDS Church Historian's Office in Salt Lake City. In 1960 a decision was made to renumber, catalog, and microfilm most of the Anderson collection and preserve only the church-related negatives and prints. After the microfilming many of the unwanted plates

were broken.[4] Fortunately, a cataloger-typist, Drucilla Powell Smith, rescued the remainder and moved the heavy glass negatives to her home.

Over the years Drucilla Smith sold nearly one thousand choice negatives of railway and other subjects to railroad history buffs and gave another three thousand plates of southern Utah subjects to a local historical society at Price, Utah; this group presented them to the Brigham Young University library in 1974. Mrs. Smith gave the remainder of the plates, nearly ten thousand images of Springville and central Utah subjects, to Leo Crandall, who bequeathed them to me in 1972. The rest of the negatives are in the possession of the LDS Church Historical Department and the Utah State Historical Society in Salt Lake City.[5]

A photographer myself, I was not only moved when I saw Anderson's work but also determined to know his story. In 1976 the opportunity to explore Anderson's past in depth became a reality when the Amon Carter Museum of Western Art, in Fort Worth, Texas, commissioned me to prepare a comprehensive Anderson exhibit and catalog. This research eventually led me to the villages where Anderson worked in order to interview his subjects' descendants. Their help in identifying ancestors and friends was invaluable.

Many of these people had difficulty believing that early photographs could be so clear and detailed, and their reaction is not uncommon. We have been conditioned to associate early photographs with grainy, out-of-focus, recopied prints. On the contrary, an inherent characteristic of photographs, from the early daguerreotypes to our modern color slides, is their sharpness of detail. Only poor conservation methods and lack of craftsmanship in copying have blurred these images. Surprisingly enough, richly detailed photographs and diaries of our grandfathers' and great-grandfathers' eras preserve a sense of reality and closeness that is not often found in the hurried snapshots and vague records of our parents' time. Despite the availability of sophisticated miniature cameras, movies, videos, and tape recorders, we may not have secured any better records of our environment and families than those produced by early photographers who took the time to make quality photographs under adverse conditions and continually changing methods of photography. These early photographers often traveled with exploring or surveying groups; some traveled from town to town to make a living; others followed the winds and seasons of change for adventure.

The rediscovery of the Anderson photographs coincides with a popular national trend toward collecting vintage nineteenth-century photographs, photographs described as the "current delight and sensation of the art world."[6] Historians, particularly, are caught up in this desire for fresh insights into the past and share with laypeople an enthusiasm for the Anderson prints.[7]

The life of the era that Anderson so carefully documented may remind us of our heritage in a number of ways, depending upon the experience we bring to his diverse subjects. Ultimately, the images found in these pages convey interpretations of human values above and beyond their aesthetic and historical content.

These moments of history still exist because George Edward Anderson was there with his camera—and his diaries. He saw with a keen natural eye but he expressed his observations with an unusual artistic vision. We see as he saw through his pictures and share many of his experiences through his personal notations (which are reproduced as they appear in the original diaries to preserve the flavor of his personality). There was little practical reason for many of

these photographs, but some impelling force caused him to stop, set up his cumbersome camera, and record. Appreciating this visual heritage should remind us that it may not be so difficult to see the unusual and the usual in our own environment; perhaps our preoccupation with living keeps us from recording these transient moments—until it is too late.

More than this, the Anderson prints should cause us to review those enduring human values, changing life styles, and environmental differences that are common concerns in every society. Such a heritage is worth preserving.

RELL G. FRANCIS

Notes

1. Rell G. Francis, "G. E. Anderson, Springville & Spanish Fork, Utah," *Popular Photography* 77 (August 1975) 2:86.

2. Letters describing the transfer of the glass plates to the LDS church in 1928–30 are found in the LDS Church Historical Department files: Ms d 4010.

3. Junius F. Wells to Elder Joseph Fielding Smith, LDS Church Historian, 16 October 1928.

4. Roger Dock, Translation Dept., LDS Church Administration Building. Interview held with Dock and Francis, 17 January 1977. Microfilming began around 1960. Possibly one-half of the plates were destroyed. Present curators are making efforts to index Anderson's work. Nearly nineteen thousand Anderson negatives were microfilmed, identified, and roughly cataloged.

5. Anderson plates in the Utah State Historical Society (known as the Bennett Collection) were the gift of John F. Bennett. In a letter from Wallace F. Bennett to Francis, 28 April 1977, Mr. Bennett explains how his father obtained the plates: "I know Father did acquire a collection of Mr. Anderson's negatives because they filled up the shelves in the clothes closet in the bedroom which I occupied, and were very much in the way. I have had the impression that Brother Anderson turned these over to Father in payment for the money that Father advanced him while he was in the East."

6. "The Romance of Old Photos," *Newsweek*, 21 February 1977, pp. 42–44. Anderson's photographs were introduced to many readers in Nelson B. Wadsworth, *Through Camera Eyes* (Provo: Brigham Young University Press, 1975).

7. For instance, sixty-four of Anderson's glass-plate negatives are in the possession of Jackson C. Thode, a Denver railroad official who has a special interest in the history of western railroads.

The Utah Photographs of George Edward Anderson

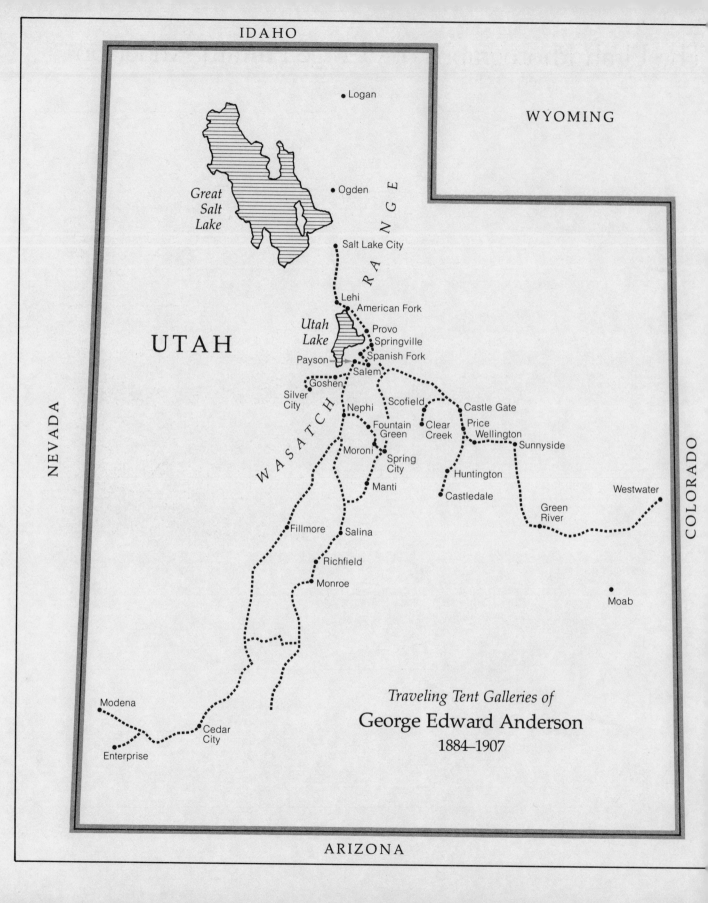

IDAHO

WYOMING

NEVADA

COLORADO

ARIZONA

UTAH

Great
Salt
Lake

Utah
Lake

R A N G E

W A S A T C H

Logan

Ogden

Salt Lake City

Lehi
American Fork
Provo
Springville
Payson
Spanish Fork
Salem
Goshen
Silver
City
Nephi
Scofield
Castle Gate
Price
Wellington
Sunnyside
Fountain
Green
Clear
Creek
Moroni
Spring
City
Huntington
Manti
Castledale
Green
River
Westwater
Fillmore
Salina
Richfield
Monroe
Moab
Modena
Cedar
City
Enterprise

Traveling Tent Galleries of
George Edward Anderson
1884–1907

Introduction

Handsome and witty, a tireless worker with a pretty wife and charming children, a devout Mormon, George Edward Anderson at one time had the "largest and most complete art studio in the state of Utah."[1] But when he died in near poverty in 1928, George Edward Anderson, the village photographer (see fig. 1), was known to many of the Springville, Utah, townspeople as an oddity and a failure. Two decades later he was virtually forgotten.

How could his life, like the matchless photographs he produced, be laid aside so easily? Anderson was a man driven to preserve both aesthetic and historical moments. His contemporaries admitted that they "were in the photography business for money; Anderson was in it for art and history. That was his failure."[2] Failure or not, Anderson was a man seemingly obsessed with his art.

Two forces appear to have dominated the direction of his art and his life: his intense religious convictions and his passion for picture taking. Since he fully supported his church and its record-keeping tradition, he applied this tradition to his camera as well as his pen. He believed the Book of Mormon to be a history of ancient American people, translated by Joseph Smith from gold plates delivered to him in 1827 by the angel Moroni, son of an ancient historian named Mormon from whom the members of the Church of Jesus Christ of Latter-day Saints (Mormons) received their nickname. Anderson, obedient to church authority, had been taught to dedicate his talents and material means to the upbuilding of the church, as are all Mormons.

With his camera and glass plates Anderson could record the building of temples, Mormon landmarks, events, and the people of his own generation with objectivity and authenticity of detail. That photography, with its unique documentary value, originated during the same period as Mormonism seemed to Anderson no less miraculous than the presentation of the gold plates to Joseph Smith.

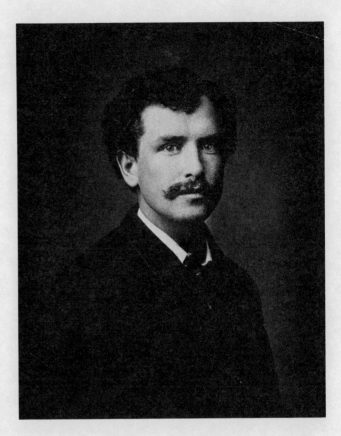

1. *George Edward Anderson, Salt Lake City, Utah, ca. 1884. One of Anderson's earliest portraits using a gelatin dry plate is this self-image taken around the age of twenty-four.*

The incredible ability of this modern medium to record the reality of life with factual precision characterized photography and separated it from all other media. Furthermore, prints from the plate negatives could be enlarged with fidelity and then endlessly duplicated or preserved in publications. Thus, from the religion-based gold plates to his secular glass plates

3

Anderson could undoubtedly find an almost sacred purpose and a focus for his documentary pursuits.

Early Photography

Obviously Anderson was not alone in his quest to record the life of his time. History welcomes and needs those who have an eye to the growth and changes in the world around them: the artists, writers, historians, and others. Indeed, students of history and life welcome the western landscapes of Albert Bierstadt, the grandeur displayed by Thomas Moran, the Indian and cowboy portrayals of Charles Shreyvogel, the strength and fire of horse and man captured by Frederic Remington, and the popular spirit of western life glimpsed through the works of Charles Marion Russell. From the mid-nineteenth century on, these great western artists recreated the excitement and native innocence of the expanding frontier. Some, like Anderson, also recorded the shifting frontier as it gave way to urbanization.

But for some historians the camera best captures the moment-by-moment changes of the western scene, so ephemerally touched by the Impressionists and so accurately caught by early photographers, and, curiously, imitated in modern days by artists and photographers.

By the mid 1870s when young Anderson uncapped his lens to record the Utah environment it appeared that the epic events of western colonization had been largely documented not only by Salt Lake City cameramen but also by various expeditionary photographers. Photographers were finding life on the frontier was changing. Indians and Mormons had already conformed to federal pressures; the Mormon empire had been settled and surveyed; and the final rail, linking the Central Pacific and Union Pacific railroads, had been laid at Promontory Summit in 1869. Anderson's

teacher and employer, Charles R. Savage, was on hand with Andrew Russell and Alfred Hart to document that historic event. Not long after the nation was linked by rail came revolutionary changes in many technological areas of American life, especially in the methods and materials of photography.

In 1871 William H. Jackson brought recognition to the wonders of Yellowstone with his dramatic landscape views; John K. Hillers explored the reaches of the unpredictable Colorado River; and Timothy H. O'Sullivan documented southwestern Indian ruins and other western landmarks. These daring photographers used cumbersome view cameras with wet (glass) plates that had to be coated on the spot with collodion, sensitized with silver nitrate, and immediately exposed and developed before the plate dried.[3]

The studio and traveling gallery photographers modified this method by providing their patrons with an ambrotype, a one-of-a-kind positive image formed by mounting an underexposed glass collodion negative next to a black backing in an ornate metal frame. Another version of the wet collodion emulsion process was the popular tintype, or ferrotype, a positive image created by exposing the sensitized surface of a black-lacquered metal plate, which allowed the cameraman to serve his customer with a cheap "while-you-wait" photograph. Other images made popular in this period were the dual pictures of the stereographs, which created a three-dimensional effect.

Artists and photographers depended heavily upon the photo gallery business to make a living in the Utah Territory, as elsewhere on the frontier. Their close affiliation and competition produced a highly artistic and technical product that is difficult to surpass today. With the advent of the commercially prepared gelatin dry plate and Eastman's roll-film camera (1879–89), the medium was further perfected for popular use.

Anderson and his earlier contemporaries arrived too late on the scene to record the historic exodus of the Mormons from Nauvoo, Illinois, to the Rocky Mountain wilderness in 1847, but such photographers as Marsena Cannon, Charles William Carter, and Charles R. Savage faithfully documented the rise of the Mormon empire in the Great Basin. The history of the West did not begin or end with the Salt Lake settlement. There were other rails to lay, mines to dig, roads and bridges to construct, and towns to build. The West was maturing. Humanity continued to produce joys and tragedies no less important than those experienced in previous eras. Typically, however, the present tends to be elusive and the dramatic changes taking place required visionary men like George Edward Anderson to quietly document them.

Anderson, who kept abreast of national events and photographic trends by his reading, was undoubtedly aware of the opposing views of the straight documentarians and the pictorialists who mimicked painting styles, but his singleminded efforts to record regional and religious events and subjects kept him largely isolated from pictorial conventions; he was determined to do his work his way. Sharply focused subject matter was consistently more important to him than arty representations. His renditions of commonplace subjects, nevertheless, contain poetic qualities that rise above mere factual reporting. Unlike the early expeditionary photographers who captured the scenic grandeur of the Utah Territory, Anderson never strayed far from his genre subjects to record pure landscapes even though he admired the beauty of his western land. Most certainly Anderson's technical and artistic knowledge of photography was firmly shaped by Savage, who had perfected his style under the influence of eastern masters, and C. E. Watkins, who is best known for his documentation of the gold rush and his landscapes of California. Had Anderson's work been discovered earlier, his reputation and efforts might well have placed him in the ranks of contemporaries such as Edward S. Curtis, known for his Indian studies, and Darius Kinsey, who recorded the logging industry of the Northwest. His work could also be favorably compared with the efforts of more recent documentarians, Arthur Rothstein and Dorothea Lange (see fig. 25, James Thompson Family).

Anderson's photographic equipment and darkroom methods were typical of the times. His view cameras, equipped with rapid rectilinear lenses, were of various sizes up to 14 by 17 inches. Contact prints made from the larger negatives eliminated the need for much enlarging. Because Anderson traveled extensively with limited equipment, he became accustomed to improvised studios and darkrooms. His usual practice was to avail himself of any quarters that could be darkened to develop his plates.

Two methods were employed for making positive prints from the negatives: The more common was to sandwich a glass negative and albumen paper in a wood printing frame, and then to expose the sandwich to sunlight to form a visible image. The positive print was next toned brown in gold chloride, fixed, washed (usually by rinsing in several changes of water in a pan), air dried, then readied for mounting. The second method, using similar equipment, was most useful on a cloudy day or for evening work. The exposures were made on more sensitive bromide paper by gaslight. The invisible latent image on the print was formed by chemical development. Enlargements could be made by adapting the view camera to be an enlarger. Gaslight or sunlight was utilized as a source of projection light and the picture was printed on bromide paper. Anderson's poor circumstances largely kept him from acquiring more modern equipment and he continued to use these processes throughout his career.

Young Anderson and Early Studio Photography

George Edward Anderson was born 28 October 1860 in Salt Lake City, Utah, to George and Mary Ann Thorne Anderson, Mormon converts from Scotland and England respectively. They crossed the Great Plains in a covered wagon, arriving in the territory of Utah in 1855. The eldest of nine children, George Edward (or Ed, as he was called) followed his father's vocation as herdsman for the city while attending school briefly during the winter months.[4]

In his teen-age years, Anderson became an apprentice to Charles R. Savage, the territory's most prestigious photographer. Savage's Art Bazar [sic] Studio employed some of Utah's best-known landscape artists, such as George Ottinger, Alfred Lambourne, and John Hafen. Under the influence of these talented painters Anderson mastered principles of art, a knowledge of light and shadow, as well as the scientific techniques of photography. John Hafen and John F. Bennett, another young apprentice to Savage, became Anderson's closest friends and advisers. Bennett, who became a prominent businessman and church leader, had a profound influence on Anderson's career by giving him money and encouragement; he also was instrumental in preserving the photographer's work after his death.[5]

At seventeen Anderson set up his own studio in Salt Lake City.[6] Assisted by his younger brothers, Stanley and Adam, the ambitious youth sold portraits —ambrotypes, tintypes, and prints made from the cumbersome wet plates commonly in use at that time.[7] Since the shop did not have running water, the developed plates and prints had to be carried up Main Street and washed in City Creek.

Within two years, Anderson won first place in the tintype photography category at the territorial fair of 1879. About this same time, George Eastman was commercially introducing the gelatin-coated glass-plate film commonly called the dry plate. This product revolutionized the photo industry, making it highly competitive. Quick to adopt new ideas, Anderson is said to have been the first in Utah to use the dry plates for portrait purposes.[8] He devised portable studio vans and tent galleries and traveled extensively through the small southern Utah communities taking photographs of local citizens. The following advertisement in an 1884 *Utah Gazetteer* described his services:

G. E. ANDERSON, PORTRAIT AND LANDSCAPE PHOTOGRAPHER. The finest portable galleries in the Country. With my improved facilities and varied experience, I am now prepared to do the finest work known to the science. I will hereafter make periodical visits to all parts of the territory. My patrons and friends will please reserve their orders for me. Due notice will be given of my visits.

Views taken of residences, public buildings, machinery, etc., at short notice and special rates. All work done by the Instantaneous Process. Copying and enlarging in oil, Crayon, and India Ink. Views, Frames, Albums, etc., P. O. Box 614, Salt Lake City.[9]

With the expansion of the railroad to the mining towns and farming communities of central Utah, it was more convenient to ship the tent galleries to the railway centers and then transport them to remote villages by horse-drawn vehicles. With the aid of his brothers and his artist friend, Hafen, Anderson established branch tent studios at Springville, Manti, and Nephi, Utah. Hafen's talents were likely employed in making scenic backgrounds for the portrait galleries or hand painting enlargements.[10]

In 1886 at Manti, where the Mormon church was building an impressive temple, Anderson started a more permanent studio known as the Temple Bazar; he advertised "Enlargements, Frames, Albums and

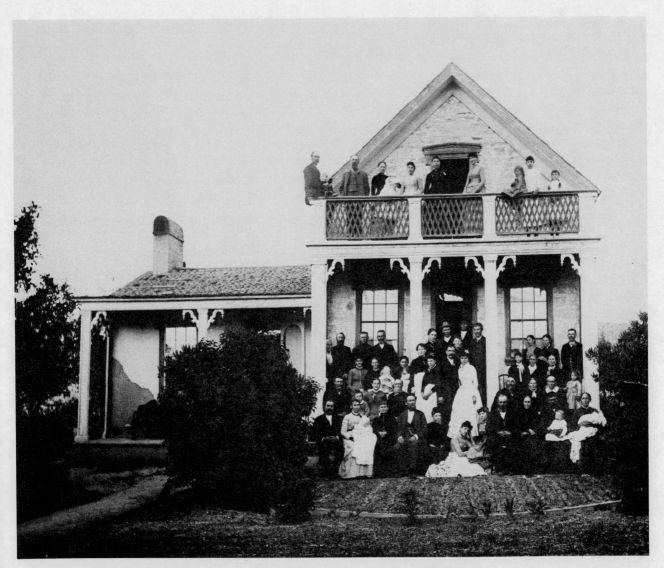

2. *George Edward and Olive Lowry Anderson, Wedding Portrait, Manti, Utah, 1888. Posing with their families at the home of Olive's father, John Lowry, at 103 East First South, are the newly married Andersons. The old stone building still stands, devoid of upper balcony and other ornate features.*

Views; Books, Stationary and Fancy notions" (fig. 3). But small merchandise and portraits were not his main interest, for he began to be obsessed with historical subjects and Mormon themes. Nearly fifty glass-plate negatives showing the stages of construction of the Manti Temple (1886–88) are evidence of Anderson's preoccupation (fig. 93).[11]

At Manti, he took special interest in one of his pretty clients at the portrait studio. Anderson fell in love with Olive Lowry, an intelligent, highly religious girl who had just returned from a year of schooling at the University of Utah.[12] Her father, John Lowry, Jr., a Mormon pioneer of 1847, express rider, Indian interpreter, sheepman, merchant, polygamist, and politician, was credited with touching off the local, three-year Black Hawk Indian War in Sanpete County in 1865 when he recklessly engaged in an argument with Chief Jake or Yene-wood, a disgruntled young Indian.[13]

The following year, on May 30, 1888, George Edward Anderson and Olive Lowry were the second couple to be married in the newly completed Manti Temple (fig. 2). This was a singular honor, since a Mormon temple marriage is believed to be a sacred ordinance that extends the marriage into the next life or eternity, thus "sealing" the couple and any offspring to one another. Later that fall, Anderson sold his Manti studio and moved his bride to Springville, where he purchased a nine-acre farm with a curious split-level cottage.[14] This home on the banks of Hobble Creek beneath the towering Wasatch Mountains was nicknamed "Artist's Retreat" by John Hafen, who shared Anderson's admiration for the place.[15]

Anderson and Hafen continued to operate their tent gallery in Springville until 1890, when Hafen received a small grant from the Mormon church to study art in Paris; the grant carried the stipulation that Hafen paint murals in the new Salt Lake Temple upon his return.[16]

Anderson next formed a partnership with Lucian D. Crandall, a businessman. In addition to maintaining tent galleries in nearby communities, in 1892 they established a permanent, adobe portrait studio on the northeast corner of Third South and Main Street in Springville (fig. 6).[17] Unfortunately, the nationwide financial panic of 1893 dashed Anderson's hopes.[18] Furthermore, the advent of Eastman's popular box camera had put the photography business into the

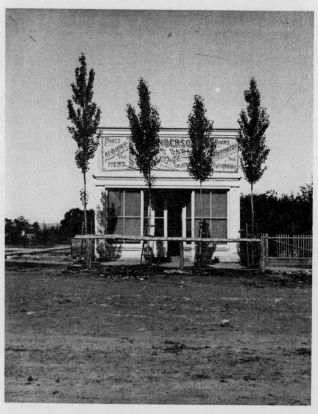

3. *Anderson's Temple Bazar Gallery, Manti, Utah, ca. 1888. After Anderson left Salt Lake City, he established this studio at 200 South Main in Manti, Utah.*

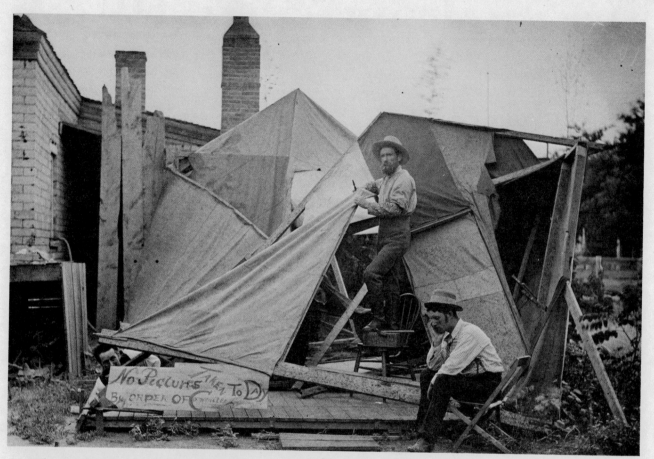

4. *Anderson's Damaged Tent Gallery, Salt Lake City, Utah, 1893. When Anderson recorded the dedication rites of the newly completed Salt Lake Temple, a gust of wind smashed his tent gallery. His father, George Anderson, Senior, is standing.*

hands of the general public. By the end of the year Crandall pulled out of the partnership and sold his share of the studio to Anderson for a thousand dollars.[19] There was simply not enough business in Springville, so Anderson was forced to resume his traveling gallery in order to survive. Now heavily in debt and away from home much of the time, Anderson decided to move his young family. He took his daughters, Eva, born in 1889, and Edda, born in 1892, from the "Retreat" to the portrait studio. Olive set up housekeeping there and assisted him in the business.[20]

The Traveling Studio

Specific information about Anderson's travels, work methods, and aspirations appears in the diaries he began keeping regularly in 1895.[21] After several false starts, he records:

Started this journal early in this year and have neglected to write regularly, many times thinking I did not have time. Have felt for years that I should keep a record of my life. . . . One other reason I have for keeping a record is that I believe where a person has a desire to do right and at regular intervals jots down the thoughts, desires, emotions and events of their life, it gives them strength and acts as a reminder of their good resolutions and brings vividly before them the mistakes of life, and the necessity of being more careful in the future.

His journals, covering nearly twenty-five years, describe the routines of business, domestic, civic, and church duties. They give excellent insight into the nature of the man. For instance, he criticized himself when he felt he had broken some spiritual law, no matter how slight. Occasional notations of hourly trivia reveal a person driven to a strict accounting of his use of time. This would be in full accord with church admonitions to make good each day. So full are his days that there seems to be little time left for personal indulgences—among them, writing in his journals or diaries.

His written aspirations complemented the visual principles of his photography. They unfolded new perspectives and horizons. Although he set his sight on eternity, he too often overlooked the everyday details of security for himself and his family. Constantly seeking to improve his contribution to his art and to his religion, he chose to forgo the comforts of life, love, and security for an obsession that would eventually estrange him from his family and community.

Anderson customarily traveled alone or with an assistant by horse and buggy to remote southern Utah villages where there was still a demand for his services. He stayed as long as two weeks in a town if he "had a good run," but often his visit lasted only a day when conditions proved unfavorable for sales or a gusty wind threatened to damage the tent gallery. His days were always long, his work varied and unpredictable. A typical day started at five. He would take portraits in the morning, tear down his tent gallery in the afternoon, and travel to the next town. There he would print circulars and spend the afternoon distributing them; then, with the help of several boys, he would erect his tent. Next he would arrange for a place to stay, eat a late dinner, catch up on his correspondence, and retire.[22]

The handsome photographer was always at home with these country people. They allowed him to use their cellars or kitchens to develop his negatives, provided him with lodging (sometimes without cost or in exchange for a photograph), or loaned him a horse and buggy to travel to adjacent villages. He consistently took part in their church meetings and socials and, on short notice, preached a sermon, taught a

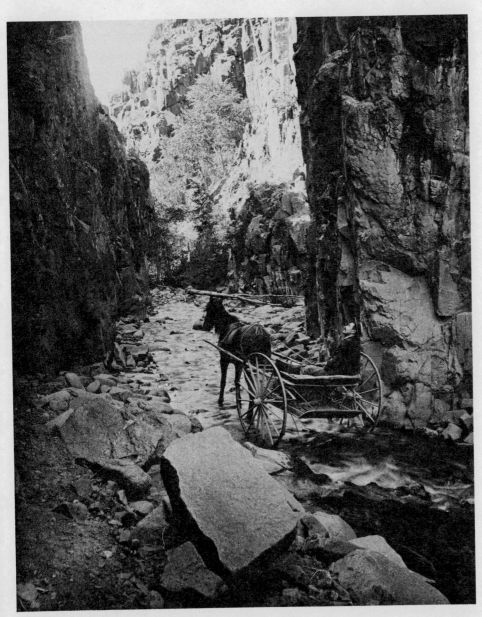

5. *Anderson at Mouth of Narrow Canyon, Monroe, Utah, 1895. Anderson's diary records "On the 4th had several sittings and went up Monroe Canyon & secured several negatives of the Narrows. Dentist J. E. Christie acting as guide."*

Sunday school class, or "made a comic speech in the Danish dialect."[23]

Town officials kindly consented to give notice of his arrival, but this announcement likely was superfluous, for the children spread the word that Anderson's photo gallery was in town. His reputation occasionally produced a welcome not unlike that reserved for a circus troupe. "The Band out and gave us several tunes before we made their picture" was Anderson's note of one such reception.[24]

It is not certain whether announcements of Anderson's gallery appearing in the town newspapers were news stories or paid advertisements. Comments by the editor of the *Salina Press* are representative of local support (fig. 18). "G. E. Anderson, the photographer, has had his tent pitched in McFadden's yard this week. The weather has been very unfavorable for his work but all the same he has done a good business. Mr. Anderson is one of the best photographers in Utah."[25]

A dozen cabinet photos, approximately 4 by 6 inches mounted on slightly larger, fancy cards, could be purchased from Anderson for about three dollars, but big-city competitors who arrived in town ahead of him could beat his prices.[26] In his diary he recorded that at Salina he discovered another gallery and "after a chat with Matson, the other photographer, finding that he had made about 40 negs, and that his price was only $2.00 per dozen," decided to move on.[27]

Travel by team and buggy was usually slow and monotonous. Occasionally, however, there were adventures to be remembered:

Made a call on several who were owing me at Salem & Payson. A rather exciting race between us and two boys with a heavy wagon occurred between Spring Lake Villa & Santaquin. We came off victorious, but not without some misgivings that we had allowed ourselves to be drawn in. Nooned at Santaquin. Nephi about 6:30 and immediately went to work and put out tent to dry and gathered & boxed

things belonging to Gallery. This tent was blown down the day of the dedication of the Salt Lake Temple, April 6, 1893. A terrific gale sweeping the country that day . . . and this is the 1st time I have put it up since [fig. 4].[28]

In the fall when the farmers had harvested their crops and were most inclined to buy photographs, Anderson put another gallery into operation, hired additional help, and gleaned the farm towns for trade. Once the plates were exposed, developed, and proofed, the orders and negatives were shipped by railway to Springville, where Anderson's retoucher and printer produced the finished work and promptly shipped it back to the village to be distributed.

In addition to his brother Stanley, who operated one of the traveling galleries, Anderson depended heavily upon the long-time services of a young deaf woman, Elfie Huntington. She efficiently managed the Springville studio in his absence.[29] Rarely, however, was Anderson satisfied with the performance of his assistants. He writes, "Many calling for work that had been promised by Adam before the holiday and it is very embarrassing, and such circumstances make me think seriously of only doing what work I can follow up closely in person."[30]

In 1895 the *Springville Independent* reported that Anderson's two galleries in Sevier County were "rolling in several sheckels per each to the fortunate Edward."[31] Profits were sometimes immediate, but most merchants, by custom, extended credit to the farmers who found it difficult to pay their debts. Anderson became the victim of such a practice, for collecting money was his greatest difficulty.

Delivered Gudmundsen picture. Poor man is going blind and there is a lady who is sick in bed all winter. They have had the money laid away for me all winter. I could not feel like taking it all so gave the lady one of $3.00 back. Poor soul, she sat down and cried, said they were too poor to see if doctor could do anything for his eyes.[32]

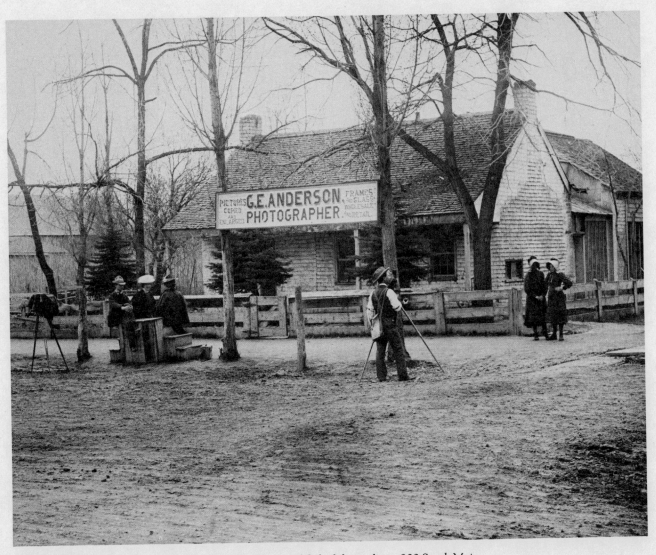

6. *Early Springville, Utah, Studio, ca. 1895. In this remodeled adobe studio at 300 South Main in Springville, Anderson and others pose. The stepdown platform at the left was built for the convenience of the patrons arriving by buggy. The picture was possibly taken by Anderson's brother, Stanley.*

By contrast, the emotion that could produce empathy for the poor could also cause him to take impatient offense at one who haggled over prices.

I must mention that a dispute arose between myself and a customer, . . . and while I think I was justified in asking her for the price of $5.50 for pictures, I think I should have made no words about it but let her have her way in the matter and thus preserved good feelings. I find that financial embarrassments, etc., have worried me so that I do not have the control of myself I should.[33]

Anderson occasionally accepted farm produce in payment for his services, but it was more expedient to make arrangements with his debtors to take their grain or produce to the local co-op stores where a system of credits could be established (fig. 41). This would, of course, enable him to trade for what he needed with the credit rather than having to carry around a supply of unnecessary produce.

During the winter months, Anderson found it profitable to move his gallery operations to the mining camps, where payroll income was more stable. He timed such visits to coincide with the miners' paydays, notwithstanding the frigid weather that hampered his efforts. "Found considerable snow. . . . It was over 3 feet deep in places where pitched the tent. . . . The 6 foot bank of snow around the tent kept out undesirable cold. I stayed there during payday and saw that much of the money goes for whiskey."[34]

Winter business trips to the farming communities in Sanpete County produced few photographs, but Anderson found the hospitable environment among his friends and relatives more to his liking. When transportation was unavailable, he visited his patrons on foot.

. . . walked to Fountain Green. . . . I had to protect my face from the cold. Reached the home of Rassmus Anderson soon after dark where I found a hearty welcome and was soon enjoying a bowl of hot milk and a good supper, not feeling the least the worst for my walk of 7 miles, but evidently it was a surprise to Bro. Anderson and his good wife that I should walk so far on such an evening but I am satisfied I kept much warmer than I would have been riding.[35]

Inclement weather affected portraiture. When the work lagged, Anderson leisurely occupied his time with letter writing, reading, and making appointments to take family pictures in homes or school groups in the vicinity.

Separated from his wife and family for extended periods, the solitary photographer was often alone with his troubled thoughts. "A most miserable struggle with my thoughts upon retiring. Consider myself very weak and hope the Lord will give me strength to control my thoughts, for I realize that it is the greatest obstacle I have to overcome."[36]

Although excessively critical of himself, Anderson made resolutions to improve his intellectual and spiritual standards; he devised admirable means to achieve these aspirations to include his wife during their unavoidable separations. He made a pact with her to safeguard their fidelity.

Fasting each Sunday morning with my wife for the Lord to give us strength (me especially) to be pure sexually before him that we may become parents of other children to His Glory. . . . For more than a year, yes several years, I have felt that I must take time to read more and take up subjects that will improve my mind. Feel my lack of knowledge in grammar, also general history & arithmetic. In fact, feel that a few years at school would be the best thing I could do, but debt makes it impossible at present. With this idea in view, I have resolved to take some time each day to studying some of the above subjects or others, and feeling that my wife would like to assist me and receive what benefits can be derived from mutually working together, I propose to make notes and send them to her.[37]

Anderson was conscientious, too, about his civic responsibilities; desiring that Utah should become a state in 1896, he expressed concern that his work kept him from returning to Springville to vote.[38]

In these photographic journeys to southern Utah, Anderson produced thousands of vivid documents of rural industry, civic groups, community celebrations, and family portraits. One element dominated—people were the center of interest in all of these compositions. Anderson liked people. His rapport with them is demonstrated by their natural, relaxed poses. Even animal portraits are somehow identified with human values. His picture of lambs titled "Catch the Sunshine" was intended to illustrate a favorite hymn (fig. 92). On the other hand, what appear first to be pure human interest compositions of comical intent turn out to be documentaries of real events and people. The old barber, his youthful customer, and rustic chair are genuine (fig. 11). Only the fake background breaks the illusion of reality.

Although the selection of photos in this volume represents a wide variety of Anderson's rural subjects of aesthetic and documentary value, two-thirds of his total output of some forty thousand negatives are studio portraits.[39] Hundreds of family albums found in Utah homes today contain one or more examples of Anderson's craft. The personalized service that he provided these villagers and farmers was more than just a family record against an artificial backdrop. The tent gallery portraits were perhaps the rural family's only tangible identity with dreams of success and luxury (fig. 68). The poorest of families could put on their only set of dress clothes, stand proudly in front of the fancy Victorian backdrop, and later see themselves as equals to the most affluent (compare figs. 12 and 78).

Possibly the most important group picture that Anderson made during his travels was the portrait of nearly four hundred surviving Mormon pioneers of 1847 who gathered on Temple Square in Salt Lake City, 24 July 1897, for the Jubilee Celebration.[40] Anderson's daughter Edda later described the problems of taking the photograph (fig. 76).

"When Dad took one of his most cherished pictures of the Utah Pioneers on the fiftieth anniversary of their entrance to the valley, C. R. Savage and several other photographers said it could not be done, . . . but he did, and each face, even at the very back stands out so clearly that each one can easily be recognized."[41]

Toward the late 1890s, when the national economy improved, Anderson established a branch tent gallery at nearby Spanish Fork, traveled less to the southern communities, and increased his advertising in the *Springville Independent*. A few samples of his promotions follow:

Boys! Get your best girl's picture put on a button, the latest fad out. Go to G. E. Anderson's and see them.

Baby Week will commence Monday at Anderson's Gallery. Bring on the little people and have their pictures taken. Prices reasonable.

If you are going to give Valentines this year, why not go to G. E. Anderson's and get 25 stamp pictures of yourself for 25 cents. Call any time.[42]

The enterprising photographer accepted all kinds of work. Among those "subjects taken on the spot" were pictures of dead children and diseased people. However, Anderson was reluctant to receive the latter assignment.

Dr. Dunn and Mayor Johnson called to see if I could go and make a picture of the smallpox patient. . . . Out to the Pest House and saw the 1st case of smallpox I ever looked upon. The attendant raised the quilt off the man's face & we could see him quite well through the window. It is surely a loathsome disease. Dr. Dalby fixed himself up and took

his camera inside & made a picture. I did not consider it wise to try a picture under the circumstances as I might expose other people.[43]

Except for such unpleasantries, these were the golden years (1897–1900) for Anderson. With business picking up he spent more time with his family. His impressionable daughters became better acquainted with his jovial spirit, his kindly ways, and engaging peculiarities. His daughter Edda recalled a typical event from her childhood.

We would drive down to catch an Oregon Short Line train, which was a mile or more west of town . . . if there was no one on the platform the train didn't stop. We were always a little late. We would see the train and hear it whistling when we were still some distance away. Papa would say, "Now whip up Nubbins, so he will go as fast as he can, and I will stand up and wave my coat." The trainman would see him and say, "Here comes George Edward Anderson, the photographer. We had better stop for him." What an embarrassing moment it was for Eva (my older sister) and me! Some of the passengers would be out on the platform, others would have windows open to see what went on.[44]

Eva, who still lives in Salt Lake City, also remembers her father's clever disguises as Santa Claus and as "Miss Potter, a noted singer from Chicago." Anderson brought excitement to the town's annual three-day bazaar in Reynold's Hall when he shaved his moustache, dressed in a fashionable gown, arrived at the train depot (the station master, fooled by the disguise, flirted with him), and gestured to a disappointed crowd at the bazaar that "she" had laryngitis but would sing the following evening. Unfortunately, Miss Potter's voice was no better the next day. The local doctor explained to the growing crowd that "her poor dear voice was still too hoarse and she must not speak so she could perform the third night" and encouraged everyone to return. Naturally, the fund-

raising event was a success. Anderson's unveiling was no disappointment to the audience.[45]

Known as a promoter of art studies, Anderson was closely associated with the founders of the Springville Museum of Art, a museum that still intrigues visitors from the state and beyond.[46] He was one of the speakers at the unveiling of the statuette of Paul Revere which the sculptor Cyrus E. Dallin had donated to his home town to start the collection.[47]

At the turn of the century, the photographer had successfully complied with the admonition of the church for its members to be out of debt. On 17 February 1900 he recorded in his diary: "Today I deposited enough in the bank to enable me to issue a check of $100.00 which payed off all the indebtedness I commenced to try to work off in 1894. . . . It is a great load lifted from our shoulders and I feel to rejoice and give thanks to my Heavenly Father."[48]

In her brief writings, Olive expressed similar gratitude and concluded, "We have been willing that Ed should go on a mission or work in any direction that the Lord desired him to when we were out of debt."[49]

A Religious Journey

On the following day, Sunday, 18 February 1900, George Edward Anderson met a new challenge. He was ordained a bishop (lay minister) of the Springville Second Ward, a ward being similar to a parish.[50] His own plans to build a new studio were put aside, and he immediately organized his two counselors and the ward members (the congregation) for the task of building a new chapel.[51] The duties of this unpaid calling were overwhelming. As the spiritual leader of nearly one hundred families, Bishop Anderson had to conduct church meetings and funerals, pray for the sick, distribute food to the poor, solicit funds and workers for the new meetinghouse, arbitrate family

16

problems, perform marriages, and engage in countless other time-consuming jobs that kept him from his business. Describing these activities, he concluded that he was "only in the gallery about 1½ hrs. during the day. Hours spent in public duties today: 8."[52]

Anderson, a small-framed man always in a hurry, attempted to accomplish a mountain of tasks that he knew were detrimental to his health. Exhausted by this demanding schedule, he often slept in the gallery after completing some late-evening photography order that he could not get to during the day.[53] New assignments came his way. He was required to photograph important Springville landmarks, public buildings, and people for a new history book of the town.[54] He accepted on-call assignments from the Rio Grande Western Railway to document important construction projects. The following excerpt from his journal illustrates the tight schedules he kept.

In the afternoon prepared to go to Green River. Mr. Thompson could not find my ticket until after train had gone so did not go until 9:25. Reached Green River about 2:15 a.m. and not being able to find anyone at Hotel made out to get several hours sleep on the floor of the station with a paper under me. At daylight rose and looked around some. A dry forbidden looking place. Walked down to the Bridge where am to make views. Then back and had breakfast. Then made a canvass of the place getting several orders for enlargements & prospects for other work. Instrument [camera] came about 12 o'clock. I then made views at Bridge and of Grader unloading and several others before the train came in. Had to pack my instrument up on the train. Home about 8. Bath and to bed.[55]

A month later, Anderson demonstrated an aptitude for recognizing the impact of historical events and produced some of the more dramatic documents of his career. He traveled to Scofield, Utah, to photograph one of the worst mine disasters in American history. On 1 May 1900, nearly two hundred coal miners lost their lives in an explosion at Winter Quarters, a small alpine village adjoining Scofield. On the following day, the impulsive photographer briefly recorded in his pocket-size diary, "Planted strawberries this morn. At the Gallery, then to the depot and concluded to go to Scofield and make views and see if could get views of the" Apparently, Anderson had no time to finish describing the vivid details of his photo-coverage that documented grim scenes of corpses carried from crumpled tunnels, pine caskets placed on porches of nearly every home or loaded on trains, sober-faced survivors, rescue teams, relatives, and grave diggers (see figs. 35 through 40).[56]

Days later Anderson mentioned a few of these events and he mimeographed a "List of Views of Scofield Disaster Made on the Spot" on the back of a one-page news supplement issued by the *Springville Independent*, briefly describing fifty-five of his pictures which were offered for sale at twenty-five to fifty cents each.[57] Anderson was also asked to serve on the committee to raise money for the miners' widows.[58]

Anderson submitted some of his free-lance photos to the media. At a time when photoengraving was only beginning to find limited use in the Salt Lake City newspapers, the *Deseret Evening News*, Salt Lake City, of 12 May 1900, without precedent reproduced five of his mine disaster photographs.[59] A subsequent publication, *History of the Scofield Mine Disaster* by J. W. Dilley, made generous use of Anderson's pictures. Credit for these photographs was given to Bedlington Lewis, an obscure Scofield photographer, instead of Anderson.[60]

Anderson served as bishop for four years—a period crowded with joys and frustrations. His idealistic attempts to manage effectively his church, home, and business affairs met with increased difficulty. Perhaps his impetuous nature coupled with his outspoken

criticism of his affiliates' imperfections could be blamed for many of the problems he encountered. He admitted that in his dealings with people "I antagonize them by the way I approach them."[61] Unable to devote sufficient time to his business, he soon found himself again in debt.

Olive, who had assisted him with the business and endured long periods of financial hardships, had to assume greater responsibility in raising the children. Her own zealous commitment to church and civic duties grew into an obsession equal to her husband's fervor.[62] As president of a local women's organization, the Woman's Hygienic Physiological Reform Association, she engaged in suffrage movements, health and food fads, healings, and other spiritualistic practices. She and her four sisters shared a commitment to the "spiritual destinies of the family" and community service.[63] Anderson, who was "inclined to be too naïve and too trusting, and let his artist's interest take priority over his need to make a living," found no fault with the Lowry sisters' alliance.[64]

Anderson stayed closer to his home to comply with his family's wishes, but his church duties largely restricted the traveling gallery business, which was handled by his brother, Stanley, and his brother-in-law, Ed Olson. Early in 1901, when business profits declined, the discouraged Anderson began to have disputes with his employees.[65] He was also forced to discontinue much of his advertising in the *Independent*, but occasional news briefs indicated that he was actively photographing in the vicinity. "The Bishop would rather take pictures than a square meal," one reporter observed.[66] In the spring of 1902, Anderson seemed more optimistic about his business success, but his profits had largely gone for replenishing his inventory of frames, glass, and books.

Just finished taking stock or adding up the results and find I am in much better condition than I thought, about

$3,500 worth of stock, etc. . . . I feel that the Lord has blest me wonderfully. . . . I see the Lord has blest me far above my merrits, and I wish to get my business in such a shape that I can devote more of my time to the building up of His Work in this part of the vineyard. I have had a great deal to contend with in the ward and from other sources, but if the Lord will show me my duty, I will try to do it.[67]

Encouraged by this accounting and the building process made on the ward meetinghouse, Anderson turned his thoughts to his own desire to build a new studio. A visit and an offer of a loan from his prosperous friend, John Bennett, gave substance to his plans. Anderson's other close friend, John Hafen, who had struggled in poverty for years trying to sell his landscape paintings, at this time also had the urge to build his dream studio-residence next to Anderson's rental home in south Springville. Anderson had already begun to tear down the old studio-home to make room for his new gallery and had recently moved his family to this location.

Hafen, encouraged by funds he had received from a two-year, one-hundred-dollar-a-month contract from the LDS church for providing easel paintings for the church buildings, was eager to improve the living conditions of his family.[68] The Swiss-born painter put up a tent for his large family in Anderson's backyard and began to build an imposing chalet-type studio. An unusual feature of the home, never completely finished inside because of lack of funds and Hafen's premature death, was its panels of nearly a thousand small windows, made from discarded glass-plate negatives cleaned of their emulsions and furnished by Anderson.[69]

Anderson's own dreams of a studio were frustrated in the spring of 1903 when his most able studio assistants, Elfie Huntington and Joe Bagley, quit to start their own photography business across the road.[70] Of course there were hard feelings over this move; An-

18

derson wrote: "Jos. Bagley told me he expected to quit in a month. I told him I thought [he] had better quit at once. . . . Did not rest very well thinking of the way Elfie & Jos. have treated me."[71]

Anderson fared no better with his two church counselors. Small disagreements over administration of church meetings began to breed disharmony. Anderson asked for the resignation of his counselors and sought guidance from his superiors. To his astonishment he was censured by local church authorities, who told him "to try it again and let the past be buried." Anderson concluded, "I felt terrible down cast in my spirits and cannot get it off my mind. I know I have tried to do my duty and hope some day my brethren will better understand me."[72] Five months later, in July 1904, Reed Smoot of the Council of Twelve Apostles met with the stake (a local church division similar to a diocese) presidency to reorganize the Springville Second Ward. George Edward Anderson resigned as bishop.[73]

The New Studio

By the end of the year the photographer had completed his new studio, G. E. Anderson Art Bazar (fig. 113). A special edition of the *Springville Independent*, 27 March 1906, characterized the gallery as the "largest and most complete establishment of this nature in the state of Utah" and reported its main features:

It is a fine two-story building and basement, generously supplied with all modern conveniences and appliances for furnishing rapid and perfect work.

The first floor is devoted to the display of works of art; frames and mouldings; education, historical and religious books of a high standard of merit; bibles, maps, charts and Sunday school literature; photographic goods of all kinds;

kodaks and kodak supplies, glass, etc. The entire second floor is occupied by the studio, with its reception room and other modern conveniences, and the basement is fitted for developing, toning and storage purposes.[74]

In addition to a glowing appraisal of Anderson's reputation and character, another article in the *Independent*, entitled "Music and Art," named Anderson as "an artist of acknowledged merit" and ranked him with John Hafen, the painter, and Cyrus E. Dallin, the sculptor, both of whom were achieving public attention for their art. Dallin's sculptures of American Indians and his famous Paul Revere models were drawing a great deal of acclaim.[75]

Yet Anderson failed to keep the studio small and free from debt as John Bennett had advised. Anderson's former employees were now competitors who advertised aggressively and offered innovative services at reduced prices.[76] Anderson's hopes turned to ashes; the new building was an illusion of success. Eva Maeser Crandall appraised Anderson's dilemma.

The studio was his dream. It was to be equipped for finishing and framing pictures from his negatives. He was a lover of history, had a wonderful memory, loved his country, his church, his friends. He longed to preserve in pictures the people, places, and events of historical value. . . . [Yet] the studio could not be built with dreams. The family could not be clothed and fed on unpaid bills for pictures he had made.[77]

Olive became the breadwinner of the family, which now included a son, George Lowry Anderson, born in 1903. Her interest in food preservation developed into a full-time job when she, her father, and neighbors started a small community cannery in 1905.[78]

In the following year Anderson was called by the Mormon church to serve a mission in England, an appointment that the photographer and his wife accepted willingly.[79] Anderson was given time to re-

solve his business affairs, and a printed circular in May 1906 announced his intentions.

TO THE GENERAL PUBLIC:
I have two objects in view in placing this circular before you. First, I wish you to know that I have completed one of the finest Photographic Studios in the West. Under our Sky-light we can group from 100 to 150 people, or arrange the light for the smallest miniature. Second, I have been called to take a mission to Great Britain, and have secured the services of W. J. Prater to look after my business. Mr. Prater recently graduated from the Illinois College of Photography, and will sustain our reputation for first-class work. We solicit your orders for Enlarged Pictures. My long experience in the business enables us to give you Artistic work and true value for your money. We are not giving an enlarged picture free, and charging three prices for a frame, but a good portrait and a suitable frame from $3.00 up. See our Dewey and Peerless Portraits. When you wish a Birthday or Wedding Present call and see our Art Pictures. I desire to thank all for your support and patronage in the past and invite you to call and see us in our new studio. Photographically Yours, G. Ed. Anderson.[80]

Again Anderson's well-laid plans were thwarted by unexpected events. In March 1907, shortly before he was to leave, another national depression caused widespread unemployment and an enormous increase in food prices.[81] The new manager of the studio produced fine-quality portraits as advertised, but he experienced heavy competition from the newly opened Huntington and Bagley gallery, and few could afford his prices. Within a year after Anderson's departure, Olive was forced to rent the studio to a furniture company and sell the "Artist's Retreat."[82]

Missionary and Traveling Photographer

When Anderson boarded a train eastward-bound in April 1907, he was supposedly on his way to England.[83] Weeks later, however, he was still in the United States, absorbed in taking pictures of historic Mormon landmarks in Missouri and Illinois. Although he had secured an extension of time for sailing to England, this change in his itinerary was not clearly understood or appreciated by his family in Utah. To Anderson, picture-taking was an important part of his missionary calling.

Not until he reached Chicago, however, did Anderson receive an official assignment from church authorities to photograph Mormon landmarks in Ohio, New York, Pennsylvania, and Vermont. When his wife wrote that she had heard he was coming home before going to England, Anderson retorted that no such thought had entered his mind. "Letter made me feel very peculiar and almost vexed," he wrote in his diary.[84]

Anderson, like other Mormon missionaries, was expected to finance his own mission. To earn funds, he made portraits of missionaries, church groups, and scenic views, and produced prints and post cards that could be used by missionaries as visual aids in proselyting or for mailing to friends and relatives.[85]

As his mission continued, he sometimes traveled on foot, carrying the heavy 8-by-10 view camera many miles a day. He traversed the wooded countryside and grain-ripened fields, often sleeping outdoors with only his camera cloth for covering, seeking the most appropriate views of the sacred Mormon sites.[86]

Rarely had Anderson recorded in his diaries and journals any concern for composition, technique, or aesthetics. These early acquired skills he had seemed to take for granted. Now his artistic concerns came to the surface. "Would like to get the views I can see in my minds's eye," he recorded. "Could not get the effect of light and shade I wished. Need painter's hand to fix colors to do it justice."[87]

His writings also meticulously described historical

details about these church landmarks as though he were reconstructing evidence to support Joseph Smith's claims. Some of these investigative notes and pictures he sent to Andrew Jenson, an ambitious historian at the church offices in Salt Lake City. Jenson, Junius F. Wells, and Anderson's friend John Bennett —all closely affiliated with church publications— were making plans to use his photographs in Mormon periodicals.[88]

Months later in the spring of 1908 when Anderson had completed his photo documentation and had sailed to England, his pictures of church landmarks in Vermont, accompanied by a pro-Mormon article, were published full page in the *Boston Sunday Globe*.[89] The illustrated article made no mention of Anderson's name but included this acknowledgment:

Recently a photographer from Utah spent several weeks in New England making pictures of scenes connected with the life of Joseph Smith to be used in a history. He had been away from home more than a year, picturing the scenes connected with the life of the prophet, chief of which are those connected with his death, at the hands of a mob, in Carthage, Ill.; his home as a youth in Palmyra, N.Y., where he announced his first revelations, and finally his birthplace in Vermont.

These views will make a record in photography to be handed down through generation after generation of Mormon believers, as the illuminated pictures of the pious monks were handed down in the earlier days of Christianity.[90]

On 27 April 1908, Anderson arrived in England on the *S. S. Canada* and was assigned to the London District.[91] He continued to take pictures to support himself and, whenever possible, he made documentary views of important English landmarks.[92] In 1909 the Mormon Deseret Sunday School Union in Salt Lake City published Anderson's church history photos in a beautifully illustrated booklet, "The Birth of Mormonism in Picture."[93] The announcement in the *Juvenile Instructor*, a Mormon publication, of the booklet emphasized its uniqueness but did not give credit to Anderson. The foreword, however, explained its purpose.

"The Birth of Mormonism in Picture" was undertaken from two motives: first a desire to preserve in attractive form photographs of places that will always be revered by Latter-day Saints; and, second, a wish to tell in a new way the wonderful story of that birth. . . .

It is the intention to publish view books on later periods in the history of the Church, so that in the end this "marvelous work and a wonder" shall have been presented in a full pictorial series from the birth of its first prophet to the present time.[94]

When Anderson received copies of the view book in England, he used them to stimulate gospel conversations with investigators. He also reproduced his photographs on post cards, tracts, and lantern slides.[95]

In October 1909, Anderson was transferred to the Dover District, where he secured quarters, as usual, that could be adapted to photo finishing.

Developed & printed some 6 dozen post cards . . . very good success. Bathroom with boards over the tub makes a very good darkroom and water handy. Red curtains at the windows raised for printing.[96]

Since he traveled a great deal, Anderson's photographic processing methods were extremely simplified. He usually contact printed his negatives by sunlight, using printing-out paper, which produced direct images easily fixed and toned with gold chloride. Although his photography was largely devoted to his missionary efforts, he frequently took time to record his impressions of the historical sites and events of Canterbury and the scenic landscapes and cliffs of Dover: "Passed over the hill and came out on the

coast. Searchlights, new moon, star, cliff. Would make a striking moonlight picture."[97] He described "passing ponds with ducks and swans; the rooks and crows in the branches overhead cawing back and forth likely about the bright sunshine."[98]

On 27 March 1910, Anderson was released from his mission by Charles W. Penrose, a member of the governing hierarchy, who encouraged him "not to hurry home but take time to visit people" and finish the work he had been sent to do. The following day Anderson received a letter from his wife, saying that she did not feel that he would come home at once.[99]

Anderson remained in England for an additional year and a half. He continued his missionary work, engaged in genealogical research, and made lantern slides of the "Birth of Mormonism" pictures for lectures which he felt were valuable "to help me accomplish the work of removing prejudice that is with the people."[100] His obsession also led him to Preston, England, to make pictures of the River Ribble, where the first Mormon converts had been baptized in 1837.[101]

Another reason for Anderson's extended stay in England was his determined effort to raise enough money to pay for the passage to America of an eleven-year-old boy, John Collett. Young Collett, who had been crippled by polio since he was an infant, was the eldest of a convert family of six children. Their father had recently died, and Anderson was deeply concerned about the young family's welfare.[102] The Colletts, like many Mormon families in England, desired to emigrate to America, but their poverty would not permit such an expense. Anderson had received other requests from parents to take their children with him to Utah.[103] Usually he offered his well-meaning verbal assistance, but his fondness for young Collett moved him to take a more active role. He was granted permission by Mrs. Collett and the new mission president, Rudger Clawson, to adopt John—the first step in his ambitious plan eventually to move the whole family to America. He wrote to his wife, seeking her prayerful approval and financial assistance for this undertaking. These transactions interfered with his own scheduled return to America on 18 February 1911, jeopardizing his right to obtain funds for his return trip from the church. He wrote:

A letter from Pres. Clawson saying would not be responsible for my return if I did not sail on the 18th. . . . Pres. Clawson's letter rather worried me. Will pray about the matter, no money from home yet. . . . Wrote to Pres. Clawson explaining my position and that I did not have sufficient money to go home on the 18th. Ask advice about taking Johnny Collett home, also that would like to visit relatives and see something of London from educational standpoint.[104]

Not until August 1911 did Anderson and young Collett sail for America.[105] They had to travel steerage. When passing through United States Customs in New York, the boy failed to respond to his new name, John Anderson, and he was sent to Ellis Island for deportation to England. Anderson desperately appealed to church officials for help. Only after anxious negotiations with Utah's senator, Reed Smoot, and intercession by President Taft in Washington, D.C., was the Collett boy released to the custody of Anderson. The photographer then sent John Collett to Utah with another returning missionary, to be taken care of by Olive while he remained in South Royalton, Vermont, to make additional church history pictures.[106]

Anderson's erratic behavior and failure to return home created a torrent of rumors in Springville. Young Collett's arrival suggested to some that Anderson had found a mistress. "There was absolutely no

truth in these accusations," says silver-haired John Collett, who still lives in Springville. "Anderson and my mother had no romantic interest in each other. George Ed was a perfectionist, too devoted to his work and beliefs to indulge in such an affair. My mother, a devout Christian, was too dedicated to her family to have such thoughts."[107]

The cool acceptance of John Collett into the Anderson family was an added burden for Olive. She had worked hard to give the girls a college education and later to finance Eva on a mission to the eastern states, apparently without any support from Anderson.[108] Her lack of warmth for the newcomer demonstrated her growing resentment toward her husband, a feeling shared by her young son, George Lowry Anderson (Lowry), now a nine-year-old boy who clashed with the headstrong English lad. When Olive learned that John's adoption papers were not valid, she decided to send the youth to Vermont to live with Anderson.[109]

John Collett became Anderson's constant companion, apprentice, and housekeeper. He soon learned to develop film, make prints, deliver pictures, cook meals, and keep a diary—an unpleasant task imposed on him by his new guardian. Much of what is known of Anderson's activities during this period is found only in Collett's early sketchy notes and later recollections.[110]

Anderson had meanwhile established a small studio at South Royalton in the vicinity of the Joseph Smith Memorial Cottage.[111] He accepted enough commercial work to finance his continued interest in documenting church landmarks. There is good reason to believe that Anderson found the business climate much more favorable outside of Utah, and he may have been trying to reduce his debts and raise money for the Collett family before going home.[112] On the other hand, the existence of hundreds of negatives of church history sites made in various seasons and from different vantage points demonstrates that much of his profits went for photo supplies.[113]

Few subjects in the area escaped the fifty-two-year-old photographer's attention. He traveled to nearby towns to picture a stone quarry, ice cutters, the maple syrup industry, and farm activities. His documentation of church sites took him to Whittingham, Vermont, to make views of Brigham Young's birthplace.[114] In 1912, a year before he and John would return to Springville, Anderson wrote to some friends and said, "I think when I reach home will have a fine line of pictures illustrating the growth of Church. . . . I hope soon to be under the shadow of those grand mountains."[115] Anderson undoubtedly foresaw a market for his many photographs in the East. And then, of course, there was the hope for more view books to be published by the church.

The Lonely Years

Anderson's "seven-year mission" was finally completed when he and John Collett returned to Springville in November 1913. Anderson attempted to patch up family ties and resurrect his studio practice, but the transition to home life was most difficult. Had he been able to put aside his photographic obsessions and resume his role as head of the family, the wounds of a failing marriage might have healed. His wife was conciliatory. "Olive and I [had] a talk before we got up. Thinks her course & work during my absence shows that [she] would support me in all that was for the uplift and improvement of myself and family. Thinks I take offense when none was intended. I must master self."[116]

However, Anderson's commitment to help Louisa Collett and her children come to America was quite another thing. He expended a great deal of effort

soliciting funds for the widow when his wife desperately needed attention.[117] When he had finally accomplished this goal, he recorded: "Sister Collett & 4 children came this morning on the San Pete train. . . . Very happy to get her and we feel that the Lord has answered our prayer."[118]

Anderson attempted to revive his foundering studio practice with the unskilled help of young Collett and his own son, Lowry. But he demanded far too much of the boys; they came to resent the meticulous standards imposed on them. When John was "readopted" by his mother and went to live with her, Anderson hired a neighbor, Ralph Snelson, as his studio assistant.[119] But he and other short-term employees could never quite please their taskmaster, nor were they satisfied with the meager wages he paid.[120]

Anderson bought a new tent gallery and again canvassed the small towns for business, but his methods were ineffective and antiquated.[121] Living in poverty, he began to depend upon his associates for a ride to the next town, a bed to sleep in, and film for his camera. While traveling in Sanpete County he recorded, "No light at hotel so I slept on hay in shed behind Co-op . . . found a good place to take a bath in willows."[122]

He was successful, however, in selling many of the "Birth of Mormonism in Picture" booklets, containing his historical pictures, wherever he traveled. He advertised these and other Mormon church books in his studio and offered one of his church history pictures as a bonus gift for each regular portrait sitting.[123] His enthusiasm for historical subjects and the hope that the church would commission him to make another view book undoubtedly distracted him from modernizing his studio methods even though he desired such conveniences. "Trying to get the enlarging apparatus, fitted some new lenses and did not get any successful pictures. . . . Think of putting in a print-

ing machine that worked by electric light. Would get on faster."[124]

Modernization did have an impact on Anderson. He was impressed with the efficiency of the automobile. When a friend gave him a ride to deliver pictures and make collections, he observed, "As soon as I am out of debt, I will get a car. Do so much more work. Must have visited 10 to 15 places in . . . 3 hours."[125] Months later, he had secured a used car. In his diary he recorded: "Washed and put away the car." But he mentions having an automobile only once more, when he briefly describes the mechanical problems he experienced with the vehicle. It was easier for him to hitch a ride wherever he went.[126]

Determined to succeed as a provider, Anderson poured his energies into gardening and remodeling the home he had purchased for seven hundred dollars. This was the same house he had rented before his mission, but the railroad company, where he had arranged the sale, had laid tracks dangerously close to the home, requiring Anderson to remove the back portion of the building to conform to the company's right-of-way standards. Edda remembered, "We used to say the trains came in our pantry door and went out the kitchen window."[127] Some of the changes that Olive and Edda desired to make in the home, however, did not meet with Anderson's approval. When Olive hired a carpenter to install a fancy picture window without confiding in him, Anderson objected: "Have felt if there could not be a better understanding, I would not remain at home."[128]

Much of Anderson's work of this period was confined to his own area, Utah Valley, where he continued to make prints of celebrations, school groups, old folks' reunions, portraits, farm scenes, and industrial developments. His most important pictures at this time were the thoroughly documented negatives of the various stages of constructing the Salt Lake–

Utah Interurban Railroad and the Strawberry High-line Canal. Anderson made nearly a hundred negatives of these vital Utah County projects, including documentation of the joint festivities that celebrated their completion in 1916 (see figs. 64 and 115), but there is little information available to show that he was paid for the work.[129]

Meanwhile Anderson's estrangement from his wife worsened when Olive's own dream of making a financial success of the cannery began to crumble. Olive was determined not to sacrifice herself and her children to Anderson's unrealistic pursuits, and she continued to exert aggressive leadership in the canning company, where she was secretary-treasurer and manager of the women employees. She and her aging father, John Lowry, the president of the company, planned and schemed to overcome unforeseen setbacks that threatened to bankrupt the expanding firm.[130] After the new cannery was completed in 1918, Anderson took a night job at the plant while trying to keep the slumping studio business alive.

Have been at Cannery as night watchman for more than two months during the run of the beans and tomatoes. Most of the night cleaning up. Since commenced on apples have had some chance to sleep, but it has been a strenuous job and has made me thin. I have commenced to feel better the last week or 10 days since I got some sleep.[131]

Over a year later when the job terminated, the sixty-year-old photographer recorded: "Bro. Crandall said would release me from Cannery, so tonight will likely be my last. Will be pleased to devote my time to the Historical pictures."[132]

Bitter family grievances surfaced along with the temporary loss of his studio to the city because of delinquent taxes.[133] Lowry, now a strong-willed teenager, had developed some habits that his father abhorred and he openly rebelled at Anderson's strict-

ness.[134] So severe was the clash between them that George Lowry was sent to live with relatives. Olive, who stood by her son, objected strenuously to his father's shortcomings. Such family disharmony crushed Anderson's spirit, for it violated his spiritual ideals and threatened his paternal leadership. The couple grew even further apart, each eating and sleeping alone. Anderson did not wish to consider divorce, another violation of church principles, but Olive was ready to give up the marriage: ". . . had a long talk with Olive, says if Lowry cannot come home, she will make a new home and wished to know how much I was willing to give her, or sell this home. Told her I had been counseled not to leave, but would feel happier away."[135]

When a new Mormon temple was completed in Cardston, Alberta, Canada, in 1923, Anderson found a natural reason for leaving home. He traveled with church authorities to Canada to photograph the dedication ceremonies of the Temple. Again he found a favorable market for his work and was tempted to buy a studio and send for John Collett to manage it, but his daughter Edda, who lived in Canada, convinced him this was not a good idea.[136] Anderson rented a basement apartment and set up a makeshift darkroom to process photographs of more temple views, church groups, portraits, and scenes of the church ranch, irrigation systems, national parks, and Indian settlements.[137]

Anderson stayed in Canada for nearly two years, much longer than he had intended, but picture taking was not the only excuse for staying away from home.[138] His diary discloses the reason for this self-imposed exile: "Before I woke this morning, I dreamed I was beside Olive my wife and she spoke to me so kind and her expression and words made me feel so happy. I could not remember the words she spoke; I thot it was 'Come close to me.' . . . I felt I

25

must write, and I could go home if I would get a welcome like that." [139]

His return to Springville in 1925, however, was not a happy homecoming. Nothing had improved. Attempts to resolve his differences with Olive uncovered deep misunderstandings.

I told her why I staid in Canada because of the way she treated me. . . . Olive speaks so unkind and often as though I was not right in the head. . . . "You sent for us to pray about bringing John Collett from England & Eunice [Olive's sister] said you was not to do it." . . . I told Olive I was out in the service of the Lord and tried to do my duty & was I not entitled to inspiration; that I prayed about it. . . . I can now understand why John Collett was sent back to me at Vermont. I did not know then. I cannot see that we did not do our part in looking after the widow and fatherless. [140]

Discussions of this kind seemed to lead Anderson to review his suppressed aspirations to make pictures for the church.

The desire I have had for years to make lantern slides of the Church History pictures and get them before the young people of the Latter Day Saints (also the missionaries could use them), comes with emphasis to me these days, and I would like to get the building I started completed so could [organize] my negatives and apparatus and get to work along this line. [141]

These thoughts had been uppermost in his mind since 1920, when church periodicals reprinted some of his "Birth of Mormonism" pictures. He seriously considered going on the road to lecture and show slides of church history subjects. [142]

In his waning years Anderson showed a determination to put his house in order. "Each day I try to put in ½ hour in making improvements at home. . . . Satisfaction comes from making things look like someone *cared*. I do not like an untidy place." [143]

He became more obsessed with health care, food, and setting goals for himself.

Up at 4:20. Fire, shook carpets, swept, made the place look tidy. Wash hands, face, neck, etc. Wash . . . clothes. Teeth brushed. 2 glasses warm water. This took about 1 hour, too long. Must get at my writing and correspondence earlier. Deliveries quicker. Aim to be at work 15 minutes after up. . . . resolve to put out $10 worth of work every day this month. . . . Try to train mind to think while busy with hands. [144]

His notes contained bits of philosophy and mottoes that constantly reminded him of good thoughts and deeds. Among these was an axiom by Herbert Hoover, who was soon to be president. "Go back to the simple life, be contented with simple food, simple pleasures, simple clothes. Work hard, pray hard. Work, eat, recreate and sleep. Do it all courageously. We have a victory to win." [145]

In the last two years of his life, Anderson made a concerted effort to make his work known and appreciated. He hitched rides to neighboring towns on Sunday mornings to attend church meetings uninvited, requesting permission to show his church history pictures to the congregations or Sunday school classes. [146] In 1926, in the company of Andrew Jenson, assistant church historian, Anderson retraced the steps of the early pioneers through eastern Utah and Wyoming to visit Fort Bridger, Independence Rock, Fort Laramie, and other pioneer landmarks, which he photographed. [147] The following summer he returned to the pioneer trail to document the unveiling of an important monument in Echo Canyon near Coalville, Utah. [148] These events seemed to promise attainment of his goals.

There was no thought of retirement, no vacation, no release from this demanding obsession. His family and friends interpreted his pursuits as irresponsible

behavior. But Anderson was the victim of his own aspirations. The spiritual, but elusive, quest to document church subjects with perfection was like a wedge that forced bitter unhappiness between him and his family. And yet his work seems not to have been recognized by the leaders of the Mormon church; Anderson's daughter Edda later stated that she had heard that some church leaders had said, "If we had only known there was a photographer like G. Ed. Anderson, how much we would have used him."[149]

In the fall of 1927 Anderson became ill with a "miserable feeling in stomach, just below the ribs, seems difficult to breathe." But he insisted upon catching a ride with church officials to Arizona to document the dedication of the Mesa Temple.[150] Olive, who had demonstrated a more kindly attitude to her husband at this time, urged him not to go, but he would not be detained. Again he stayed on in Mesa for several months after the dedication to get better pictures of the temple landscaped with spring flowers and to photograph other subjects in the area.[151] His failing health also kept him from returning home. "Most of time in and out of bed," he wrote. "Must have movements. Tried walking on hands and knees. Exertion. Had to lay over on my side, strength gone."[152]

On 9 May 1928, George Edward Anderson died of dropsy or heart disease shortly after he was brought home from Arizona.[153] His funeral was conducted in the church house that had been built while he was bishop. Among the many tributes given were these appropriate words by Eva Maeser Crandall:

The ground he traveled was hallowed to him. I can almost hear him say, "I must have a picture of this sacred spot. . . . When I return all will be changed. Some of these old landmarks will be obliterated. Who will see them as I see them now?"[154]

George Edward Anderson, the traveling photographer, had finally come home, but his glass-plate negatives of Arizona, Canada, and England were left behind.[155] Although a few prints of these subjects exist, the locations of the plates are at present unknown.

Irony always seemed to be a constant in Anderson's life. Now, some fifty years after his death, recent exhibits and the publication of Anderson's prints by the Smithsonian Institution, Boston Museum of Fine Arts, and Photokina of Cologne, Germany, have popularized the western photographer's work and reputation.[156] People are now appreciating and enjoying his glimpses into a half-remembered world.

Perhaps the most avid collectors of Anderson's prints today are his relatives. Anderson's two surviving children, Eva Anderson Noyes and G. Lowry Anderson, proudly display their father's art and have a different attitude toward his life and work. "I know now that Dad was trying to fulfill himself," says Eva. "His dream to inspire young people with his pictures has finally come true."[157]

Like other photographers and artists around the turn of the century, Anderson felt a compulsion to record his times. This he accomplished. Surely, George Edward Anderson will be remembered as the village photographer who was in the business for the love of art, history, and his religion.

Notes

1. "Largest and Most Complete Art Studio in the State," *Springville Independent* (Special Illustrated Edition Devoted to the City of Springville and Its Resources), 27 March 1906.
2. O. Blaine Larson interview with Francis, 12 November 1976. Larson, a Provo, Utah, photographer, is the son of T. C. Larson, who made this statement; he was an apprentice to G. E. Anderson.

3. For further information on early photographers and their methods, see Ralph W. Andrews, *Picture Gallery Pioneers, 1850 to 1875* (New York: Bonanza Books, 1964) and *Photographers of the Frontier West: Their Lives and Works, 1875 to 1915* (Seattle: Superior Publishing Company, 1965); William Welling, *Collectors' Guide to Nineteenth-Century Photographs* (New York: Macmillan Publishing Co., Inc., 1975); Beaumont Newhall, *The History of Photography* (New York: The Museum of Modern Art, 1964); and James D. Horan, *The Great American West* (New York: Bonanza Books, 1959).

4. Noble Warrum, *Utah Since Statehood*, vol. 3 (Chicago and Salt Lake: S. J. Clarke Publishing Co., 1919), pp. 589–90. Contains a short biography of Anderson.

5. Senator Wallace F. Bennett to Rell G. Francis, 19 April 1977. Senator Bennett is the son of John F. Bennett.

6. Kate B. Carter, comp., *Our Pioneer Heritage* (Salt Lake City: Daughters of the Utah Pioneers, 1975), p. 275. In volume 18 there is a chapter called "Early Pioneer Photographers." Anderson's studio was located over the Daynes Music store at 62½ Main Street in Salt Lake City.

7. See Robert Taft, *Photography and the American Scene* (New York: The Macmillan Company, 1938); *Light and Film* (New York: Time-Life Books, 1970), pp. 72–76; J. B. Schriever, ed., *Complete Self-Instructing Library of Practical Photography* (Scranton: American School of Art and Photography, 1909). George Edward Anderson (GEA) seldom mentions his technical knowledge of photography in his journals and diaries. A few examples of his tintypes and collodion wet plates are extant, but there is no evidence that Anderson made stereographs.

8. See note 1; mention is made in article.

9. *Utah Gazetteer and Directory* (Logan, Ogden, Provo, and Salt Lake City), 1884, p. 442.

10. B. F. Larsen, "A Brief from an Illustrated Paper on the Life of John Hafen," *Utah Academy of Sciences, Arts, and Letters* 12 (December 1939), p. 93.

11. Glass-plate negatives of the Manti Temple are in the collections of Rell G. Francis, Brigham Young University, and the Historical Department of the LDS church.

12. Edda Anderson Brandley, "Biography of Olive Lowry Anderson," *Pioneer Histories*, vol. 4 (Springville: Camp Springville, Daughters of Utah Pioneers, 1953), p. 154. This typescript volume is located at the Springville Pioneer Museum, Springville, Utah.

13. S. George Ellsworth, *Utah's Heritage* (Santa Barbara and Salt Lake City: Peregrine Smith, Inc., 1972), p. 286. Also, Lowry Nelson, "Boyhood in a Mormom Village," MS, Brigham Young University Special Collections, 1972, p. 27.

14. Carter, p. 283.

15. Brandley, p. 156.

16. William Lee Roy Conant, Jr., "A Study of the Life of John Hafen, Artist" (masters thesis, Brigham Young University, 1969), pp. 6–12.

17. Utah County Recorder, Deed Book 23, p. 299.

18. Financial crises twice stopped Anderson's plans for growth.

19. Utah County Recorder, Lot description of N.E. half of Lot 4, Blk 5, Township 33 of Springville, #45, shows that Lucian D. Crandall conveyed the lot to GEA for $1,000, 27 December 1893. Debt paid by 4 April 1896.

20. Brandley, p. 157. In 1895 GEA asked his father, described as a lonely man separated from his wife, to move into the Artist's Retreat. Later he leased it to his brother-in-law, James C. Reynolds, who defaulted on payments, causing unhappy family disputes.

21. Anderson's journals, and diaries in some instances, are located in three collections. For ease in reference they will be assigned a code initial, location, date, and/or page, wherever available. This entry comes from G. Lowry Anderson (his son) and will be cited as GLA. Lowry holds eleven volumes, dated 1895–1904, 1908–1909, 1914–15, and 1919–20. The citation would then read GEA Diary, GLA, 3 January 1895, p. 1. The second set is in the possession of the LDS Church Historical Department, Salt Lake City, Utah. Including fifteen volumes, dating from 1908 to 1928, these diaries will be referred to as LDS. The third set resides with the Daughters of the Utah Pioneers Museum, Salt Lake City, and includes three volumes, dated 1907 and 1909–11. These will be cited as DUP.

22. GEA Diary, GLA, 28 March 1895, p. 45.

23. "Old Folks Party," *Springville Independent*, 21 September 1899.

24. GEA Diary, GLA, 8 May 1895, pp. 43–44.

25. *Springville Independent*, 24 July 1896 (reprint from the *Salina Press*).

26. "Business Briefs," *Springville Independent*, 30 September 1897. Anderson's prices are listed in this news item. His prices remained about the same throughout his career, with the exception of his studio prices in Vermont, where he charged four dollars per dozen cabinet photos.

27. GEA Diary, GLA, 16 August 1895, pp. 54–55.

28. GEA Diary, GLA, 14 August 1895, pp. 52–53.

29. GEA Diary, GLA, 23 September 1895, pp. 73–74. In this instance Miss Huntington is assisting GEA with the traveling studio on location.

30. GEA Diary, GLA, 11 January 1897, p. 147. Although his brother Adam, or Ad, had his own studio in Provo, Utah, GEA apparently still had a business affiliation with him.

31. *Springville Independent*, 11 October 1895.

32. GEA Diary, GLA, 26 March 1896, p. 139.

33. GEA Diary, GLA, 2 January 1895, p. 3.

34. GEA Diary, GLA, 15 and 16 February 1895. Winter Quarters is a small coal-mining hamlet adjoining Scofield, Utah, which is about sixty miles southeast of Springville.

35. GEA Diary, GLA, 28 January 1895, pp. 17–18.

36. GEA Diary, GLA, 21 March 1896, p. 135.

37. GEA Diary, GLA, 25 August 1895, p. 59; 10 January 1897, p. 145.

38. GEA and his wife were active Democrats who participated in civic projects and showed a keen interest in local and national issues. In 1914 Anderson was asked to run for precinct justice, but he declined because he was away from home too often (14 October 1914).

39. GEA produced far more negatives than first estimated. Much of his work produced in Chicago, Vermont, England, Canada, and Arizona cannot be located; therefore, the estimate of forty thousand negatives, which could include early unidentified tintypes, ambrotypes, etc., is a conservative guess.

40. "Pioneers of 1847 Who Attended the Big Jubilee Ten Years Ago," *Deseret Evening News*, 24 July 1907. Anderson's group portrait was reproduced in this issue. Readers were encouraged to identify the pioneers in the photograph and return the names to the newspaper. In 1920 GEA was still trying to sell copies of this picture: "Many very much interested in Pioneer Picture. One gentleman gave me 50 cents for explanation." GEA Diary, GLA, 24 August 1920, p. 89.

41. Edda Anderson Brandley, "From Edda's Notes for Club Talk," n.d. Typescript is in the possession of Louis Brandley, Raymond, Alberta, Canada.

42. These items occurred in "Business Briefs," *Springville Independent*, 9 December 1897, 20 January 1898, and 9 February 1899.

43. GEA Diary, GLA, 14 February 1900.

44. Brandley, "From Edda's Notes."

45. Eva Anderson Noyes to Rell G. Francis, 22 September 1975.

46. The Springville Museum of Art in Springville, Utah,

contains works by Dallin, Hafen, and other prominent local and western artists.

47. GEA Diary, GLA, 27 February 1903. John Hafen's painting was also presented as a gift on this same date. See "Red Letter Day," *Springville Independent*, 5 March 1903.

48. GEA Diary, GLA, 16–18 February 1900.

49. Olive Lowry Anderson, unpublished journal, consisting of a few pages of handwriting made by Olive of this year only, in possession of Margaret Brandley Larson, Orem, Utah, 18 February 1900. Olive also speaks of the earlier partnership affiliation with Lucian D. Crandall which originated the debt.

50. "Springville Second Ward" (manuscript record at LDS Historical Dept.). This record indicates that GEA was ordained a bishop by Apostle George Teasdale on 18 February 1900. GEA's counselors were Simon E. Dalton and Phillip H. Boyer.

51. The *Springville Independent* of 8 March 1900 reported that "G. Ed Anderson is collecting large quantities of building materials and will commence the erection of a substantial business block. The town do grow." At this same time GEA and his family moved from the studio to 243 South Fourth East Street in Springville to live with Ed Olsen and his wife, Dora, Olive's sister. See Diary, 10–13 April 1900.

52. GEA Diary, GLA, 1 September 1900.

53. GEA Diary, GLA, 11 November 1900, p. 65: "A dizziness in my head the last few days. Not doing as I should. Must be more careful." 14 November 1900: "Eyes quite weak . . . slept at the gallery." 25 April 1903: "My eyes very sore or pain me today. Could hardly see to focus." Anderson often recorded concern for the well-being of his ward members and other Springville residents. For several months he visited an elderly sick woman and gave her a blessing each night, 25–28 December 1903.

54. Don C. Johnson, *A Brief History of Springville, Utah, from Its First Settlement, Sept. 18, 1850, to the 18th Day of September, 1900* (Springville: William F. Gibson, Publisher, 1900), p. 110.

55. GEA Diary, GLA, 2 March 1900. Springville contractors had an important part in constructing many of the railroads in Utah: "Several jobs for the Rio Grande Railroad in Colorado and New Mexico were dotted for miles with Springville sub-contractors using Springville men and outfits." From *Memories That Live, Utah County Centennial History*, compiled by Emma N. Huff, Daughters of the Utah Pioneers, Springville, Utah, 1947, p. 355.

56. "Nightmare in a Utah Mining Town," *The Miners* (New York: Time-Life Books, 1976), pp. 122–35. This book uses fourteen of Anderson's photos of the Scofield mine disaster. The original glass-plate negatives are owned by Robert Edwards, Salt

Lake City, Utah. See also GEA Diary, GLA, 2 May 1900.

57. GEA Diary, GLA, 2 May and 5 May 1900 and *Independent Supplement*, vol. 9, no. 38, Springville, Utah, 24 May 1900.

58. GEA Diary, GLA, 7 May 1900. GEA also records that he "spotted out and numbered the views of Scofield Disaster." It was Anderson's habit to inscribe the name of the subject carefully on the emulsion side of the negative or have his assistants do this important clerical work.

59. "Winter Quarters After the Explosion . . . Vivid Scenes Photographed for the News by G. E. Anderson," *Deseret Evening News*, 12 May 1900.

60. J. W. Dilley, *History of the Scofield Mine Disaster* (Provo: Skelton Pub. Co., 1900), pp. 16–17.

61. GEA Diary, GLA, 13 January 1900.

62. "Church Worker Succumbs at Springville," *Salt Lake Telegram*, 14 November 1945. See also Brandley, p. 161.

63. Sarah Boyer, Secretary, "Woman's Hygienic Physiological Reform Assn. Roll Book (and Minutes)," no. 3, 1895, in possession of Margaret Brandley Larson, Orem, Utah.

64. Bennett to Francis. Senator Bennett also said: "I know that Father felt very close to Mr. Anderson, and in a way felt very protective toward him. He regarded him as a wonderful photographer, but felt that he had no real sense of sound business practice . . . but after all, wasn't this a fault he shared with most artists."

65. GEA Diary, GLA, 16 January 1901, p. 132.

66. "Terse Tales of the Town," *Springville Independent*, 11 July 1901.

67. GEA Diary, GLA, 13 March 1902.

68. B. F. Larson, p. 94. See also Conant, pp. 23–28. Conant estimates that Hafen received approximately $14.50 each for his paintings from the LDS church. Many of Hafen's paintings listed by the artist as being in the possession of the church cannot be located today.

69. GEA Diary, GLA, 12 November 1903. Anderson felt sorry for Hafen's family, who temporarily lived in a tent while building their home: "Raining during the night. Home for breakfast about 9. Moving things out so Sister Hafen can move into our fruit room. Too cold for her to be in tent with little children." See also, Rachael Hafen Beutler interview with Francis, 12 April 1977. Although this account is told by the Hafen family, Anderson recorded reusing glass negatives for window glass. This also makes it difficult to estimate Anderson's total output of photographs.

70. *Springville Independent*, 14 May 1903. Bagley started to work for Anderson in 1900 for twelve dollars per month, "after that $25 per month for 1 more year. Then $40.00 if business will permit of it." GEA Diary, GLA, 10 September 1900. The Huntington-Bagley studio was first located near the Harrison Hotel. Later, in 1907, a new studio was built at the corner of First South and Main streets.

71. Diary entries intermittent December 1902 through February 1904. See also Tess Hines Garrison with Rell G. Francis, "Elfie Huntington Bagley—Lady Photographer," *Mountainwest*, January 1977, p. 23.

72. GEA Diary, GLA, 13 February 1904.

73. Springville Second Ward, CR mh 8660, LDS Historical Dept., 24 July 1904. This account also records: "There has been some difficulty between the bishop and his counselors, which produced unpleasant feelings and dissatisfaction among the members of the ward." John Frank Bringhurst was made the new bishop.

74. *Springville Independent* Special Edition (note 1).

75. Rell G. Francis, *Cyrus E. Dallin: Let Justice Be Done* (Springville: Springville Museum of Art, 1976). It is interesting to note that Anderson (1860–1928), Hafen (1856–1910), and Dallin (1861–1944) were frustrated by many disappointments and financial failures that forced them to seek fame and fortune outside their native state of Utah.

76. *Springville Independent*, 14 February 1907. Huntington and Bagley advertised colored pictures of the local mountains: "We go anywhere, anytime, to photograph anything."

77. Eva M. Crandall, "Our Village Photographers," a brief typescript sketch of life of Anderson, in the possession of Louis Brandley, Raymond, Alberta, Canada.

78. "Springville Canning Factory," *Springville Independent* Special Edition. M. E. Crandall is listed as the president and general manager. John Lowry, Olive's father, is the vice-president. See also Brandley, pp. 161–62.

79. Brandley, pp. 162–63.

80. G. Ed. Anderson, "Anderson's Art Studio" (printed circular), Spanish Fork Press, May, 1906. Circular among other GEA memorabilia located at the LDS Church Historical Department in Salt Lake City.

81. Again, as earlier, finances affect Anderson's plans.

82. Eva Anderson Noyes interview with Francis, 19 February 1977; *Springville Independent*, 19 March 1908; and a mimeographed handbill (n.d.) announced the sale of "The Artist's Retreat" as "Ideal for a pleasure resort." (Ms d 1771, Folder 12, LDS Church Historical Department.) Utah County Recorder's Office documents show that Olive Anderson sold this property to A. L. Porter on 22 October 1908 for $1,125.00.

83. GEA Diary, DUP, 20 April 1907.

84. GEA Diary, DUP, 27 June 1907, p. 118. Apostle George Albert Smith met with GEA in Chicago and advised him to continue taking views of the church history subjects and made suggestions for his itinerary. GEA wrote, 29 June 1907, p. 119, "I told Apostle Smith that I had thought of writing President Penrose of the English Mission and telling him why I was so long in coming, what I was doing, etc. He said to do that."

85. GEA's diary lists several scenic views made in the Chicago area. Pictures he made of the Niagara Falls, 11 August 1907, and many others have not yet been located.

86. GEA Diary, DUP, 17 August 1907, p. 169. See also George Ed. Anderson, "Boy in the Picture of the Sacred Grove," *Improvement Era* 23 (May 1920). This article, illustrated with Anderson's photograph of the Sacred Grove in Palmyra, New York, describes how GEA was led to photograph the area of the grove where Joseph Smith was believed to have had his first vision.

87. GEA Diary, DUP, 13–17 August 1907, pp. 167–70.

88. GEA Diary, DUP, 21 August 1907, p. 179. See also W. C. Spence, transportation agent for the LDS church, to GEA at Ford's Studio, Randolph, Vermont, 24 March 1908. Spence instructs Anderson to arrange for passage to England and thanks him for pictures of historical Mormon sites that John F. Bennett has given him. Letter is on microfilm, Cr 256, LDS Historical Department. Bennett was at that time a member of the Sunday School General Board and treasurer of the church organization that published the *Juvenile Instructor*. Junius F. Wells, former editor of the *Contributor*, another church magazine, was in charge of erecting a cottage and a thirty-eight-foot-tall granite memorial to the memory of Joseph Smith, who was born in Sharon, Vermont, in 1805. This project, completed in 1905, commemorated the one hundredth anniversary of Smith's birth. Anderson also traveled to Lebanon, New Hampshire, to record where Joseph Smith had temporarily lived in 1811. Two photographs of this area are included in a bound volume of church history photos that Anderson presented to President Joseph F. Smith, which is now located in the church historical department.

89. "Shrine for Mormon Pilgrims in Vermont," *Boston Sunday Globe*, 10 May 1908, included in the *Juvenile Instructor*, 43 (1 July 1908), pp. 246–53.

90. *Boston Sunday Globe*, 10 May 1908. The *Millennial Star*, 28 May 1908, mentions Anderson's contribution to the *Globe* article.

91. *Millennial Star*, 70 (30 April 1908), p. 284, records Anderson's appointment and arrival in the British Mission.

92. GEA Diary, LDS, May 1908. While in England, GEA recorded photo data in a small handbook called *Welcome's Photographic Exposure Record and Diary*, 1908. This book lists nearly three hundred negatives taken between April 1908 and May 1912. Anderson's address is listed as H. 32, Cann Hall Road, Leytonstone (Ms D 1771, Fd. 11, LDS Historical Department).

93. John Henry Evans, "Birth of Mormonism in Picture," Scenes and Incidents in Early Church History From Photographs by George E. Anderson of Springville, Utah, Presented by Him to the Deseret Sunday School Union (Salt Lake City: Deseret Sunday School Union, 1909), engraved and printed by Williamson-Haffner Co., Denver, Colorado.

94. "Mormonism in Picture." See also "Items of Interest," *Springville Independent*, 7 January 1909. This news item reported that Olive Anderson displayed "an album containing photographs taken by her husband in and about the historic localities connected with L.D.S. history in New York, Vermont, Penns., Ohio, Illinois, and Missouri. The album is to be presented to Pres. Joseph F. Smith by Mrs. Anderson at the request of her husband."

95. GEA Diary, DUP, 5 August 1909 and 27 December 1909. GEA also showed view books of Chicago, Niagara Falls, and others to his investigators.

96. GEA Diary, GLA, 8 December 1909. The red curtains served as a safelight. This account suggests that Anderson was printing his pictures by sunlight. Later when he returned to the London area he made his apartment serve as a darkroom, 17 May 1910. Other times he used the basement facilities of the missions headquarters, called Deseret, in London. (Pictures of this building made by Anderson exist in the LDS church archives.) Missionaries usually travel in pairs, but Anderson, almost fifty, often traveled alone.

97. GEA Diary, GLA, 19 November 1909.

98. GEA Diary, DUP, 1 March 1910.

99. GEA Diary, DUP, 27–28 March 1910.

100. GEA Diary, DUP, 12 April 1910. GEA also recorded: "Looking over views and deciding what to do about making up slides for lantern lecture."

101. GEA Diary, DUP, 16 February 1910. See also letter from Anderson to Christian Otteson, 12 September 1914; letter is in possession of Elma Otteson Collard, Huntington, Utah. Anderson tells his friend of his picture-taking experiences in the East and in England.

102. GEA Diary, DUP, 18 February 1911. GEA recorded: "Pray the Lord that the child can go with me if it is for his good & will be a blessing. Sister Collett has her hands full."

103. GEA Diary, GLA, 8 August 1908 and GEA Diary, DUP, 5 February 1911: "An interesting chat with Bro. & Sister Britton. They would like Dora to go to Utah with me."

104. GEA Diary, DUP, 9–11 February 1911.

105. *Millennial Star*, vol. 73 (1911), p. 508.

106. John Collett interview with Francis, 15 June 1977. Also Eva Anderson Noyes to Rell G. Francis. Eva and her husband, Lyman, were on a mission in the eastern states and were on hand to welcome Anderson and young Collett in New York.

107. Brandley, p. 162. Anderson's writings describe two incidents in which he is accused of romantic impropriety while on his mission. In Chicago in 1907 it was rumored that he proposed marriage to a young woman. Anderson denied knowing the woman, but upon having her picture pointed out to him he admitted that he had been introduced to her briefly, but he had no further conversation with her. He was troubled by this accusation. In England, 28 February 1911, he recorded: "Pres. Monson had heard from two sources that I had written to some young ladies sending them kisses and saying my home would not be complete without them. I told him no truth in it whatever and could not construe any letter I had written to mean anything of the kind. Think it refers to what Anne Lawton had read to Miss Allen, also Miss Evans. Rather unsettled me." GEA Diary, DUP. Admittedly Anderson speaks earlier of controlling his thoughts and passions, but there is no real evidence that he succumbed to temptation of this kind. John Collett and other Springville residents vouch for Anderson's high moral character.

108. Brandley, pp. 162–63.

109. John Collett interview.

110. John Collett, unpublished journal, 1912–14, in the possession of Mr. Collett. When John could not recall his previous day's activities he would record: "Did the same today as I did yesterday."

111. Anderson spent much time at the cottage, taking pictures of tourists, missionaries, and other church groups.

112. A printed circular advertised Anderson's commercial work: "Photographs On the Spot—Night or Day, To the Citizens of South Royalton and Neighboring Towns, For One Week, Wed Dec. 6 to Tues. Dec. 12 I will be at the P. S. Belknap Studio from 11 A.M. to 4 P.M. If you wish a picture of your Home and Surroundings, the Cozy Nooks in the Parlor, the Family Group, the School, the Bride and Baby, I will be pleased to serve you. Pictures Copied and Enlarged. Friday the 8th . . . Baby Day. Saturday the 9th . . . Old Folks Day. Bring this Circular with You and Get Special Rates. Remember Our Dates. First Class Work, My Motto. Respectfully, G. Ed. Anderson, Portrait and Landscape Photographer." Circular is now located at LDS Church Historical Department. A listing of his prices shows that his rates were higher than his Utah prices.

113. The LDS Church Historical Department, Salt Lake City, Utah, has over five hundred of Anderson's negatives of the historic church sites. Many of these are of the South Royalton area.

114. An inventory of Anderson's prints (P 726 fds. 135–146, LDS) shows 166 prints of these subjects, including the site where Brigham Young lived. Anderson also demonstrated some photojournalistic tendencies by submitting an article and pictures to the *Improvement Era*. George Ed. Anderson, "The Last Celebration of the 24th at the Birthplace of the Prophet Joseph Smith," *Improvement Era*, vol. 17, pp. 122–27.

115. GEA to John Tuckett, 22 May 1912, letter in possession of Gene Tuckett, American Fork, Utah.

116. GEA Diary, GLA, 1 November 1914.

117. GEA Diary, GLA, 26 November 1914.

118. GEA Diary, GLA, 19 March 1915.

119. G. Lowry Anderson interview with Francis, 16 April 1976; see also John Collett interview. There is good evidence that GEA harshly mistreated Lowry and John in his attempts to discipline them. GEA also describes these actions in his diaries: "Lowry helped me hitch up but not very pleasant about it. . . . I hurried him up with the buggy whip. Did not make me feel very well."

120. GEA Diary, LDS, 7 May 1915; 9 August 1915.

121. GEA Diary, GLA, 12 and 15 October 1914; 26 November 1914.

122. GEA Diary, LDS, 31 August 1914.

123. "Ideal Christmas Presents" (a printed circular by Geo. Ed. Anderson, phone 62j, Springville, Utah) located in DUP Museum Library. GEA also advertises "Boy Scout Cameras and Kodak Supplies, Films Developed and Printed."

124. GEA Diary, LDS, 21 November 1916. Anderson and a temporary assistant, Edwin Poulsen, attend the Eastman School of Photography workshop in Salt Lake City in 1916. "It was splendid, full of instruction that was helpful," GEA recorded (GEA Diary, LDS, 30 and 31 May 1916). In an interview with Earl Lyman, a long-time photographer in Salt Lake City who knew Anderson, and Francis, 10 March 1977, Lyman observed that in 1914 Anderson's studio equipment and methods were outdated. Anderson used the dry-plate negatives until his death in 1928. Very few nitrate (flexible) films are in his collection of negatives.

125. GEA Diary, LDS, 1 November 1916.

126. GEA Diary, LDS, 1 April 1918.

127. Brandley, p. 164. Also GEA Diary, GLA, 31 October 1914.

128. GEA Diary, LDS, 30 November 1916.

129. GEA Diary, LDS, 26–27 May 1916; 6 July 1915: "Made several negs today—also of men working the interurban driving spikes." See also news of celebration of canal-railway completion: "Many Provo People Spent Day in Payson," *Provo Post*, 26 May 1916.

130. Brandley. Mrs. Brandley speaks of Olive's concerns for the canning factory, which failed sometime around 1930: "And one grave disappointment that was especially hard for her to bear was that they had been forced to sell her beloved canning factory, and that the stock she had worked so hard to accumulate was worthless. Even when mother was taking care of the home and keeping Eva on her mission, she would never draw out all of her wages, but would let them remain and become stock because the factory was having such a hard time financially. . . . canning hours for mother were from seven in the morning until seven, eight, or nine at night, with washings, ironings, and our home to keep up besides," pp. 166–68.

131. GEA Diary, GLA, 1 December 1919.

132. GEA Diary, GLA, 22 August 1920.

133. Utah County Recorder's Office, Tax Sale Book 204, p. 24.

134. GEA Diary, GLA, 10 January 1920. Lowry is sent to live with his sister, Edda Brandley, in Canada, but stays only a short time.

135. GEA Diary, GLA, 7 September 1920.

136. GEA Diary, LDS, 2 October 1923.

137. Anderson's diaries and receipt books show photographic services for the Canadian Sugar Beet Company, United Irrigation Company, and other agencies (GEA Diary, LDS, 9 April 1925). A midnight scene of the Cardston Temple by GEA is a striking example of his church pictures made in Canada.

138. GEA to John Collett. Anderson tells Collett that he expects to come home in June 1924 to attend the exercises at the opening of the Ironton Steel plant. Apparently Anderson wished to document this new industrial development located between Springville and Provo.

139. GEA Diary, LDS, 9 October 1924.

140. GEA Diary, LDS, 30 September and 30 December 1926. GEA speaks of his wife having symptoms of mental illness at this time. Edda Brandley confirms this fact and describes her mother's struggle to overcome this illness that lasts until about 1934. See Brandley, pp. 166–70.

141. GEA Diary, LDS, 5 November 1925.

142. GEA, *Improvement Era*, vol. 23, May 1920. "Sketches Commemorating the Centenary of the Prophet Joseph Smith's First Vision," *Brigham Young University Quarterly*, 16 (1 May 1920). The cover and several pages of this booklet include Anderson's photographs of New York and Vermont. Mentioned also in GEA Diary, LDS, 3 December 1920, 3 November 1920, and 15 December 1924.

143. GEA Diary, LDS, 12 February 1921 and 6 January 1926.

144. GEA Diary, LDS, 6 January 1926. This is typical example of trivia Anderson often includes. Also, GEA Diary, LDS, 10 February 1927. GEA sold newspaper subscriptions for a contest to supplement his income, but had difficulty collecting the money. He also records, on 4 January 1927, that he is writing letters "to those I am owing, when I would pay."

145. This motto was among Anderson memorabilia (Ms d 1771. fd. 13, LDS Historical Department).

146. GEA Diary, LDS, 4 September 1927.

147. Andrew Jenson, *Autobiography of Andrew Jenson* (Salt Lake City: Deseret News Press, 1938), pp. 588–92, and GEA Diary, LDS, 13 July 1927.

148. "Ceremony Marks Unveiling Canyon Monument," *Salt Lake Tribune*, 17 July 1927. The *Tribune* published two of Anderson's photos of the Echo Canyon Pioneer Monument unveiling. Anderson displayed a bent for photo-journalism with one of the views.

149. Brandley, "From Edda's Notes."

150. GEA to President Heber J. Grant, 17 October 1927: "I would like very much to go to Mesa, Arizona, and make pictures of Temple during the 3 day service, I feel that I could make a picture record that would be in harmony with the sacred service, and that would be very valuable to the Church. Bro. John F. Bennett suggested that a duplicate set of negs should be made and filed in the Church Office Building." (LDS Historical Department.)

151. GEA Diary, LDS, 9 December 1927. Anderson records on this date: "Moved my things to Sister Bell Bacus, 248 E 2nd St. Looks like would be most convenient place I have had to finish in. Use the bathroom & only have to darken one window." On 21 March he writes: "Beautiful view can be made of the temple now flowers are coming out around the pond." Apparently Anderson's reputation in Arizona was well known. A woman writing to him from Thatcher, Arizona, simply addressed the envelope: "Mr. Anderson the Photographer, Mesa, Arizona" (letter and envelope in LDS Historical Department files).

152. GEA Diary, LDS, 23 April 1928.

153. The Springville City Record of Deaths indicates that GEA died of a heart disease.

154. Eva M. Crandall, "Our Village Photographer."

155. GEA to Andrew Jenson, Church Historian, 17 October 1927. Anderson indicates that his negatives are still in Canada. In his letter to John Collett in 1924, GEA notes that his negatives are still in England.

156. See Nelson B. Wadsworth, "A Village Photographer's Dream," *Ensign* 3 (September 1973), 9:40. In 1976, selected Anderson mural prints were shown at the *Photokina* cultural exhibit in Cologne, Germany, as part of *Popular Photography*'s presentation for "Discoveries and Rediscoveries" in which photography magazines from all nations were invited to submit outstanding work recently published in their periodicals. And *Frontier America: The Far West* (Boston: Department of American Decorative Arts and Sculpture, Museum of Fine Arts, 1975), both exhibit and catalog.

157. Eva Anderson Noyes.

Portraits from the Past

7. *Clyde Sisters, Early Seamstresses of Springville, Utah, 1885. Typical of Anderson's early tent gallery portraits, with painted backdrops and accessories, is this picture of Elva Jane Clyde (Mrs. Phillip Houtz) and Mary Loretta Clyde (Mrs. Abner Thorn), the daughters of William Morgan Clyde. The sisters wear clothes they made for themselves.*

8. *Martha and George Washington, Springville, Utah, 1889. A regal portrait of Miss Dougall and Master Crandall was produced in Anderson's tent gallery. The photographer required absolute stillness during the few seconds needed to expose the photograph.*

9. *Merrill Caffrey, Springville, Utah, 1890. This portrait of the son of James Caffrey, a Springville businessman, is a fine example of Anderson's personalized studio work.*

10. *Philo Dibble and Wife, Springville, Utah, ca. 1890. Philo Dibble (1806–1895), a body guard for the Prophet Joseph Smith, was shot once by angry mobs in Illinois, but he lived to describe early Mormon events in his traveling show which included sculptured busts of the martyred Smith brothers.*

11. James Walker, Town Barber, Mt. Pleasant, Utah, ca. 1892. Parley P. Fullmer and his barber are moved into the tent gallery, possibly for better light. Walker, born in England in 1833, had his regular shop in Mt. Pleasant, Utah.

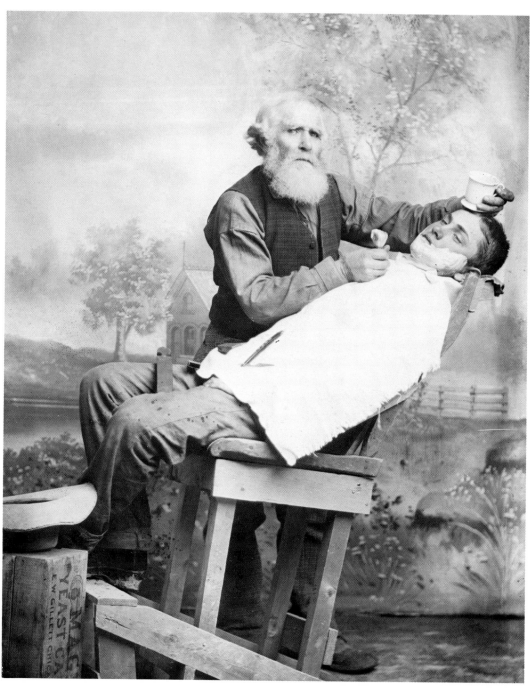

12. Thomas Potter and Wife, Scofield, Utah, ca. 1894. Dressed in their best clothes, Blacksmith Potter and his wife momentarily step out of their humble environment into the stylish scenery of the studio. Animals are usually blurred in pictures of this kind because of the long exposures.

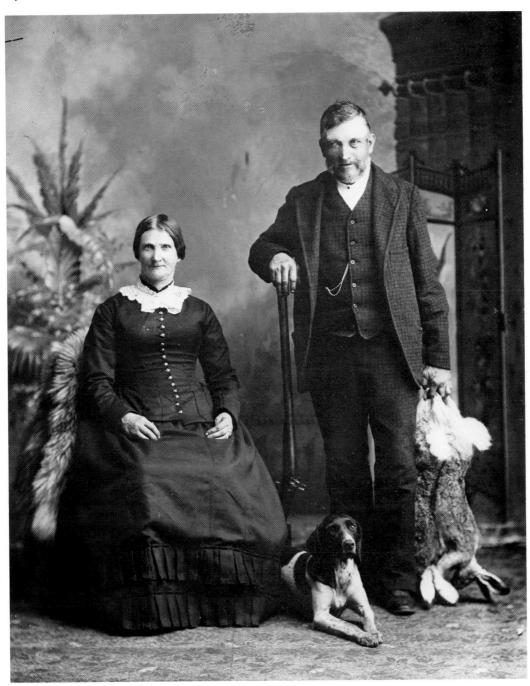

13. *Sarah Nisonger and Spinning Wheel, Santaquin, Utah, ca. 1894. In 1852, Sarah (1812–1895) left a good job in a shirt factory in Dayton, Ohio, to join the Utah Mormons. She lived in a primitive dugout, washed clothes for soldiers at Camp Floyd, carded wool, and wove cloth for a living. Indians once invaded her cabin, ten miles out, but did not bother her when she calmly pitched a pan of water over some of their fighting dogs.*

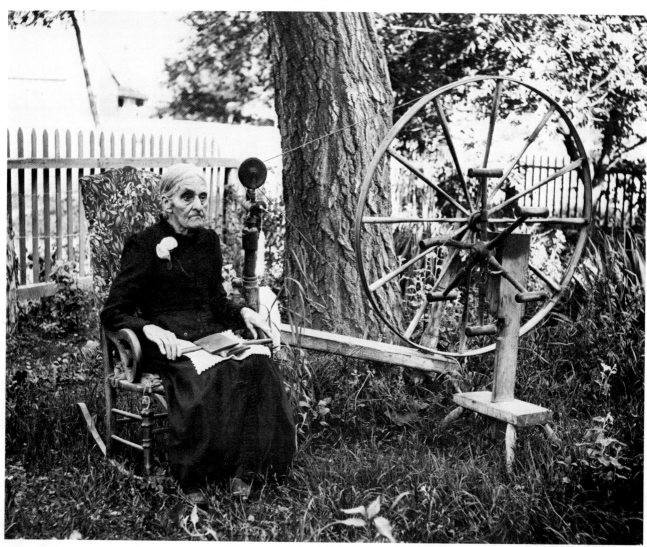

14. *F. P. Whitmore, Town Marshal and Butcher, Springville, Utah, ca. 1895. A more official Indian fighter was Franklin Perry Whitmore (1834–1902) Springville's popular butcher and town marshal.*

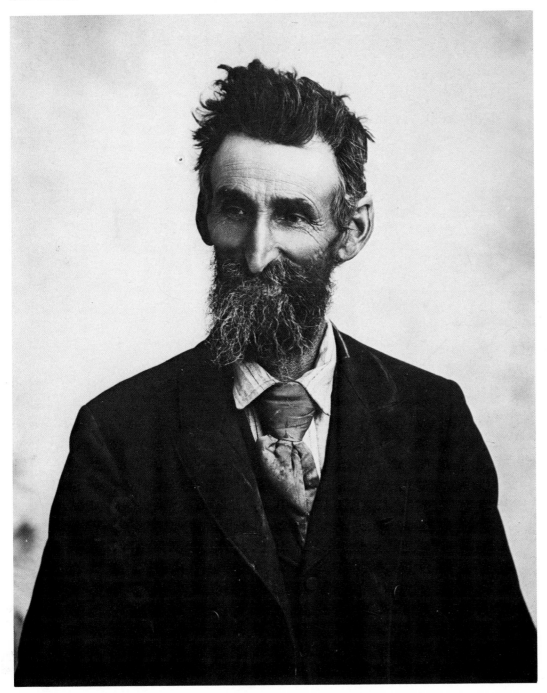

15. *Foster Funk and Girl Friend, Orangeville, Utah, ca. 1895. Seventeen-year-old Foster Funk (1878–1935), a long-time resident of Manti, found the girls over the mountain at Orangeville more to his liking. Funk married a home town girl some nine years later.*

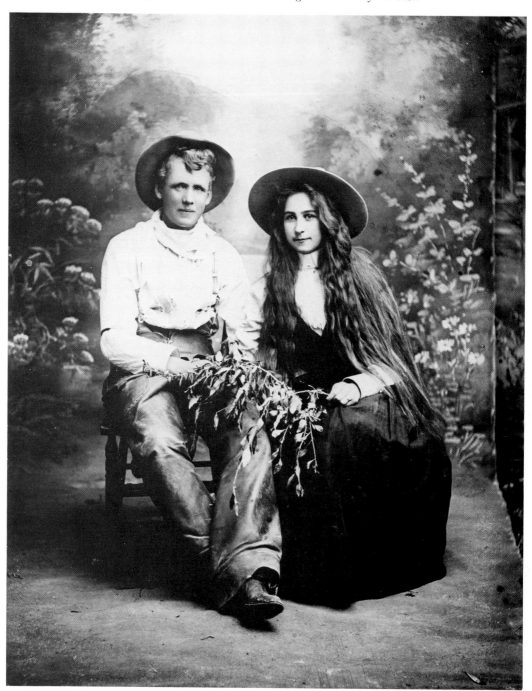

16. *Tillie Houtz, Statehood Queen, Springville, Utah, 1896. Perhaps Anderson himself selected Matilda (Tillie) Houtz for her unofficial reign to celebrate Utah's statehood in 1896. The twelve-year-old girl's mother, Matilda Streeper Houtz, owned a millinery shop across the road from Anderson's studio.*

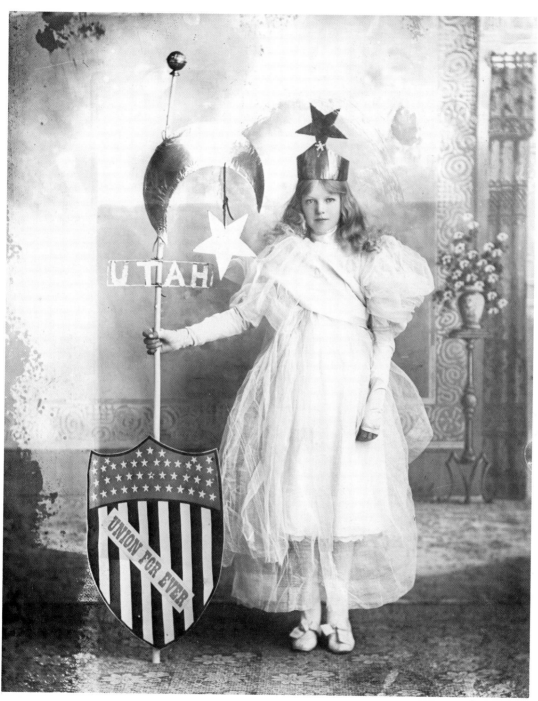

17. *Miner's Meat Market, Springville, Utah, ca. 1896. The Miner brothers, Moroni Albert and Marian Francis, the sons of Moroni Miner, pose in their meat market at 150 South Main. The curious onlooker at left is identified as F. P. Whitmore, the former butcher.*

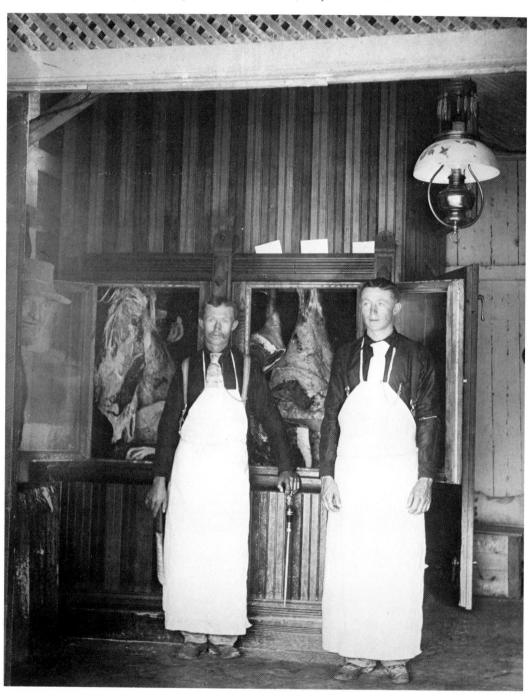

18. Salina Press Editors, Salina, Utah, 1897. Anderson likely traded this photo of the veteran newspaperman Arthur E. Howard and his young editor for the good advertising he received in the pages of the Salina Press.

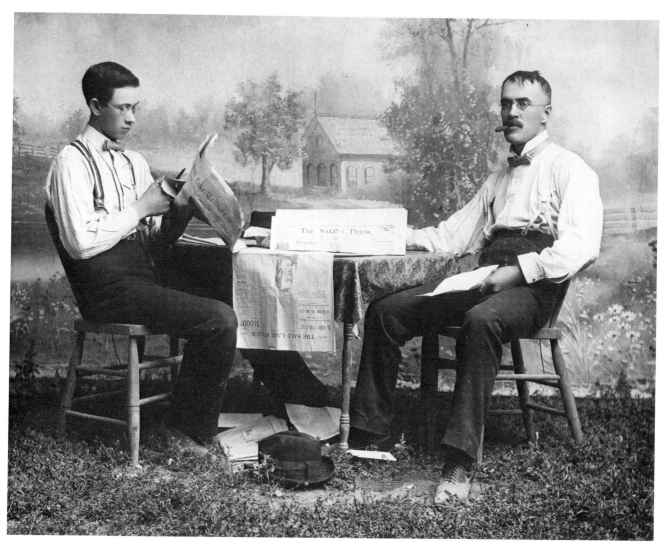

19. *Mrs. David Felt and Daughter, Springville, Utah, 1898. Evidence of middle-class well-being is shown in this portrait (David Felt was the editor of the* Springville Independent *for a short time). Anderson's selective focus effectively subdues a cluttered background. The outdoor setting in soft focus is not unlike the painted studio backdrops.*

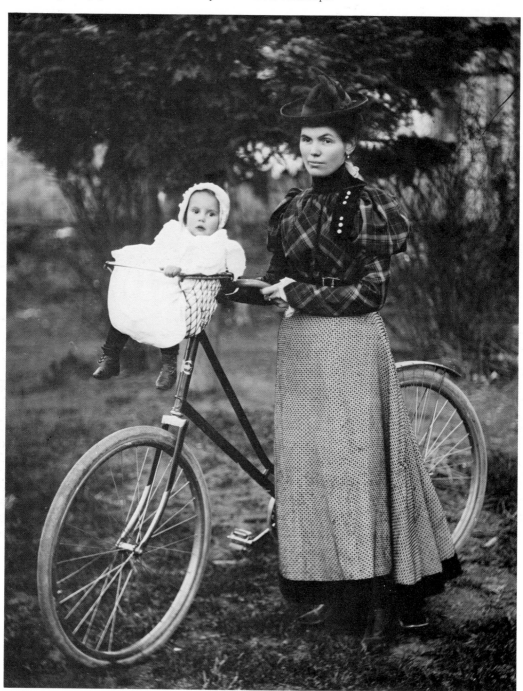

20. *Anna Thompson and Soldiers, Springville, Utah, 1898–99. Anna Thompson, the name written on the glass negative, is probably the dominantly posed figure in this picnic setting. The two Spanish-American War volunteers very much resemble Stanley Staten and Barney Dougall who were among the first to enlist in 1898. Dougall, at right, returned home safely in 1899, but he was killed the following spring in the Scofield mine disaster.*

21. *Libbie Whitelock and Mirror, Springville, Utah, 1900. The portrait of Libbie Whitelock is another fine example of the individuality Anderson sought to achieve in each of his sittings.*

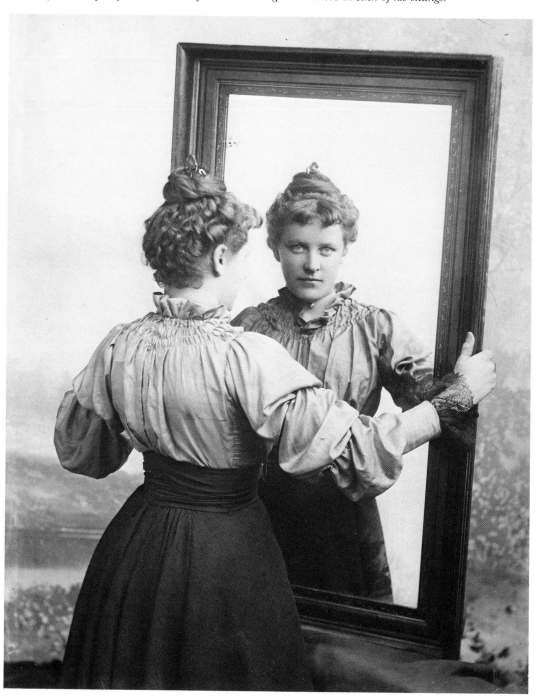

22. *Cedar Fort Graduates, Payson, Utah, 1900. The young man, John Morgan, is the teacher of these graduates: left to right, Mabel Busbee, May Wilcox, and Rebecca Cook.*

23. *Ether Blanchard Home, Springville, Utah, 1902. Achilles Blanchard, like his father the violinist, wrote poetry and songs; he made the harp from a bicycle frame. At the right are his mother, Sylvia, and her mother, Margaret Goff, who lived to be 106.*

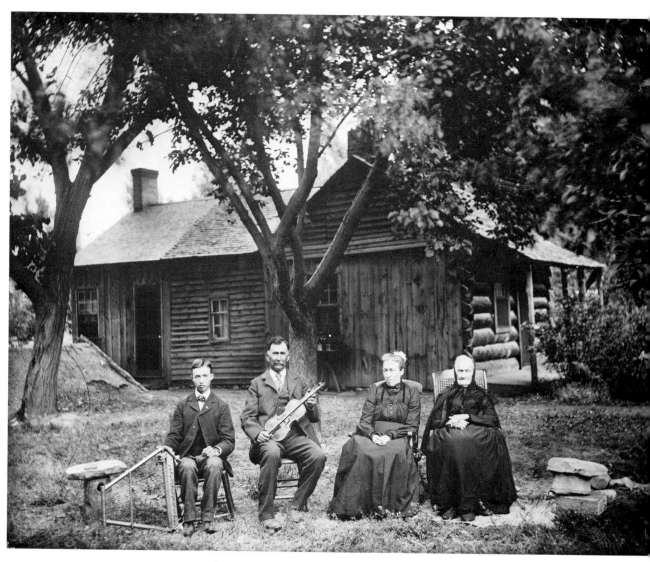

24. Eva Anderson and Friend, Springville, Utah, ca. 1904. Eva Anderson, daughter of the photographer, takes the part of the boy and dances with her friend, Geneve Hyde, in a pose suitable to the Victorian setting.

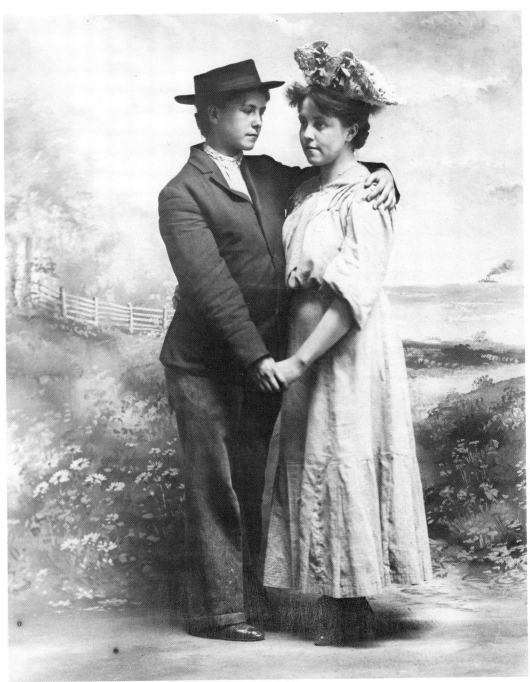

25. *James Thompson Family, Elsinore, Utah, 1904. This intimate photograph of a Utah farm family expresses character, life, and reality—traits that a fuzzy snapshot of the next generation would lose.*

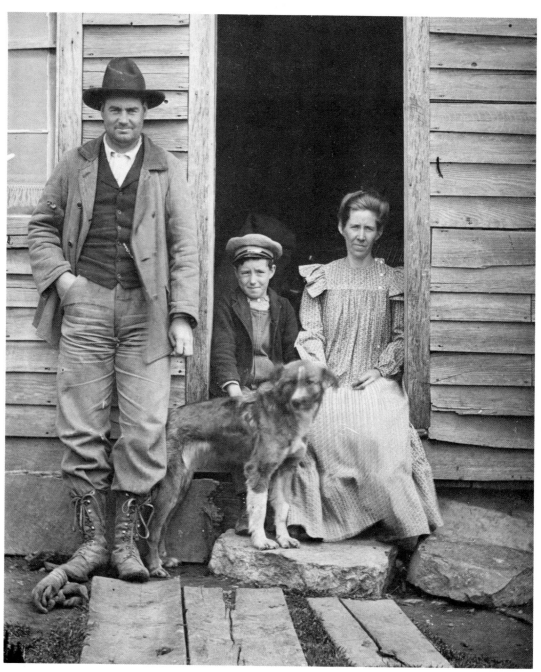

26. *Wainwright Bakery, Springville, Utah, 1905. Newly arrived from England, William Wainwright and his family established a bakery in Springville. His shop, with its European atmosphere, evokes nostalgia for unsliced bread, costing five cents a loaf.*

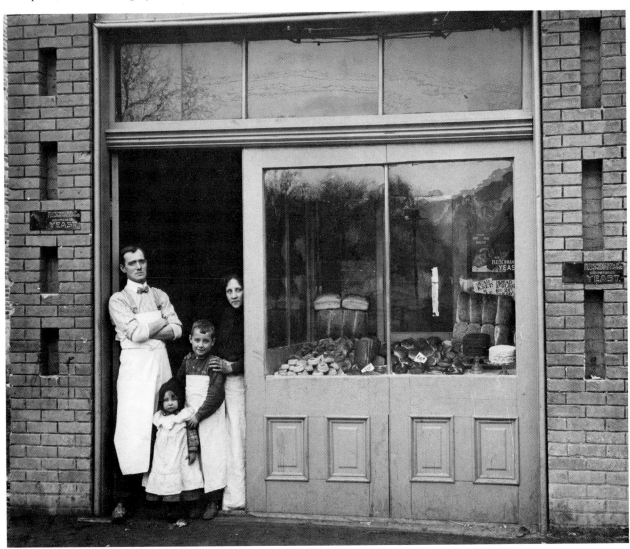

27. *Mrs. Albert Manwaring and Children, Springville, Utah, 1903. Albert Manwaring, in England serving a mission for the LDS church, received a copy of this photograph from his wife and children.*

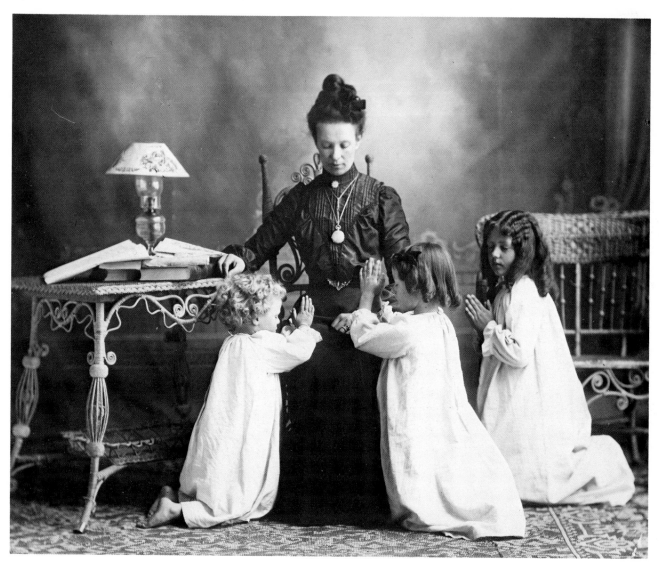

28. *Teenage Boys and Snakes, Springville, Utah, ca. 1913. Anderson might have expressed his approach to human interest subjects of this kind in a more creative way with modern equipment, but his portrait of these teenage boys, Reed Clements, Louis Tranchell, and Gilbert Dillingham, and their water snakes is startling enough as it is.*

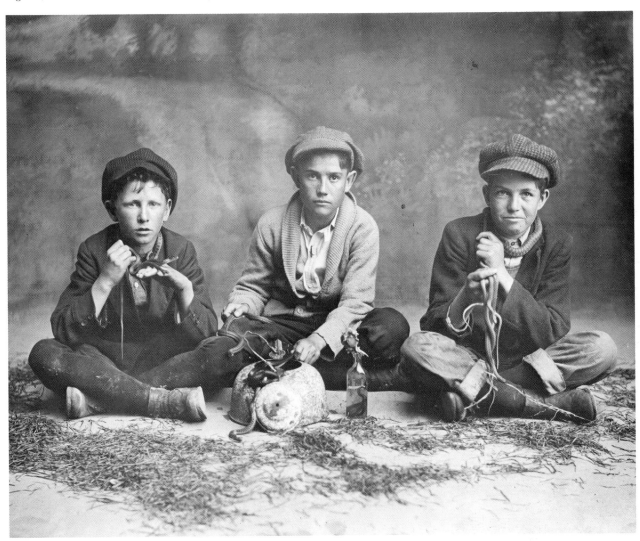

29. *Fred Weight and Bear, Springville, Utah, 1916. The bear, killed in the mountains above Springville, was not nearly so heavy as the log that had to be carried up the studio stairs. The photographer propped its head up with a piece of glass, undoubtedly hoping it would not show. But the objective eye of the camera saw it all.*

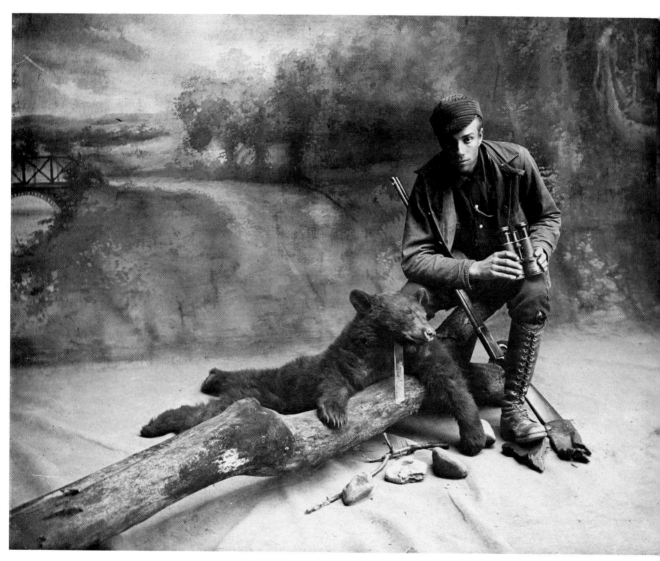

30. *Springville's First Racer, Springville, Utah, 1914. A favorite entry in the Fourth of July Parade, this early automobile would share the dusty roads with horses and buggies.*

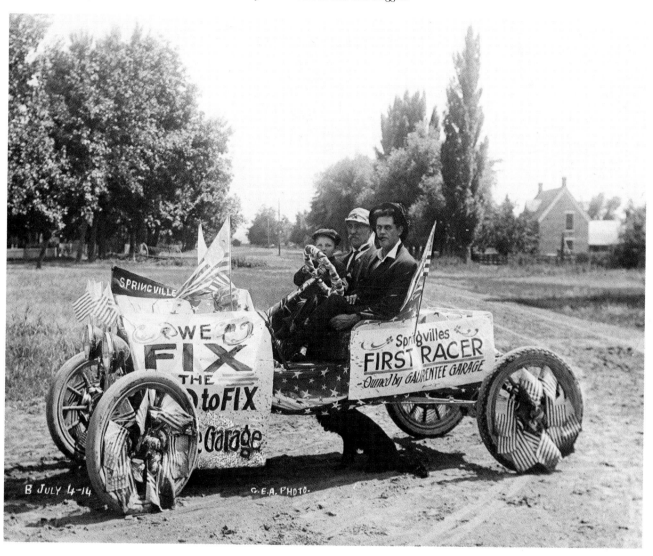

31. *Springville Women, Springville, Utah, ca. 1914. Older residents recognized the Great Western Washing Machine. The women are Sarah Anderson, Nell Starr, and Ida Alleman Taylor, who was a school teacher.*

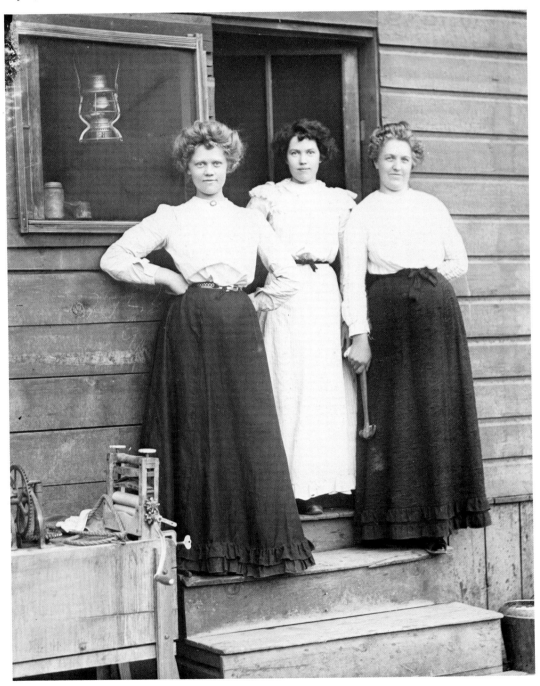

32. *Laura Jasperson and Flag, Goshen, Utah, 1917. Posed with a letter and pictures from her son who served in the infantry in World War I, Laura Alice Dean Jasperson displayed her own patriotism by making flags, two of which she sent to the governor of Utah and to the President of the United States.*

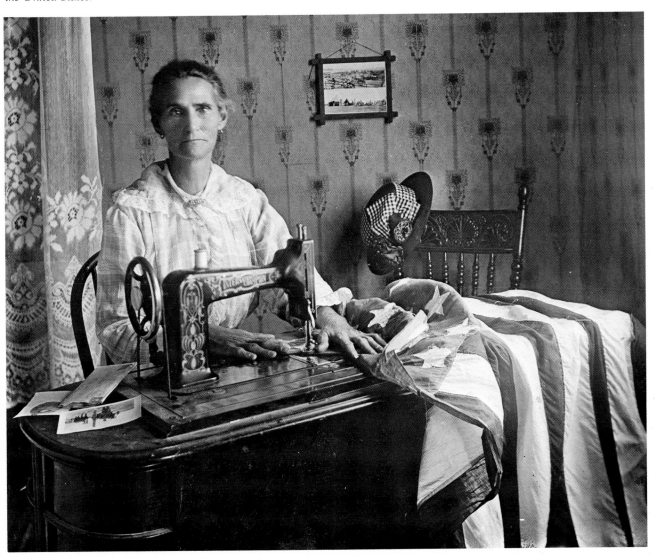

33. *Cowgirls, Springville, Utah, 1917. While the young men served their country in World War I, the young women "kept the home fires burning" with occasional fun and songs. Shown left to right are Belle Anthon (Sumsion), Velma Blackett (Jarvis), Elsie Munn (Thyret), and Julia Alleman (Caine).*

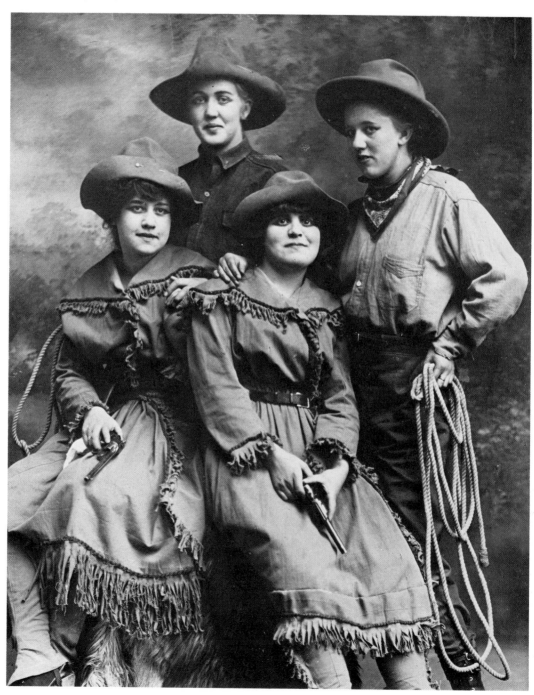

34. *Child of S. M. Davis, Springville, Utah, n.d. Children's portraits constituted a large amount of Anderson's work. More unusual than the child's costume is the natural smile on the lips. Animated expressions could rarely be captured with time exposures without causing a blur.*

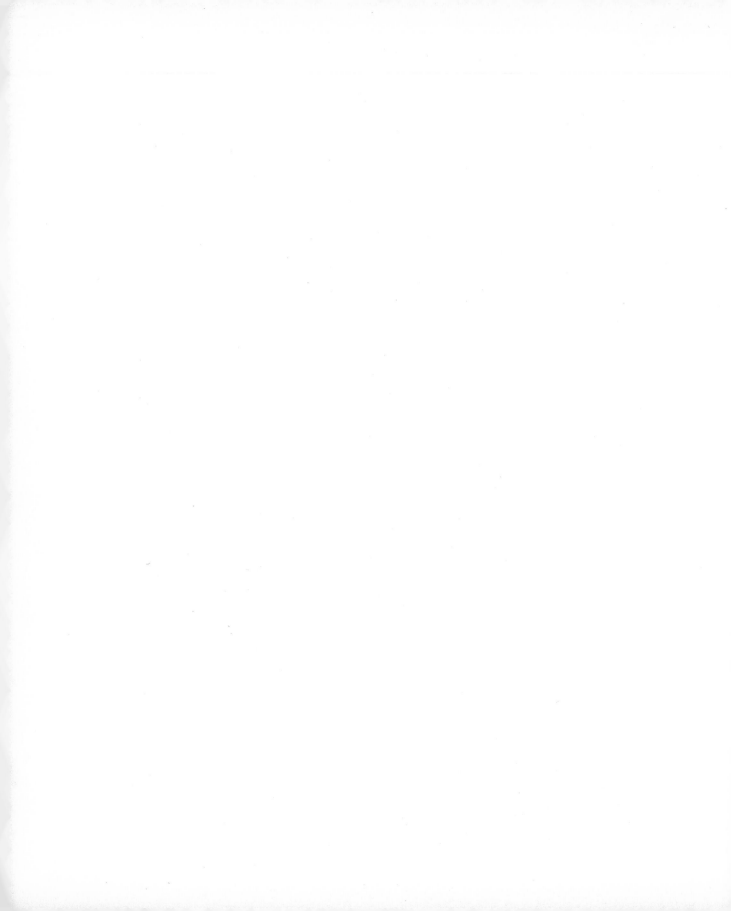

Scofield Mine Disaster

35. *Carload of Flowers, Scofield, Utah, 1900. The body of James Gatherum of Provo, Utah, a victim of the Scofield mine disaster, is loaded on the train which brought a carload of flowers from all parts of Utah.*

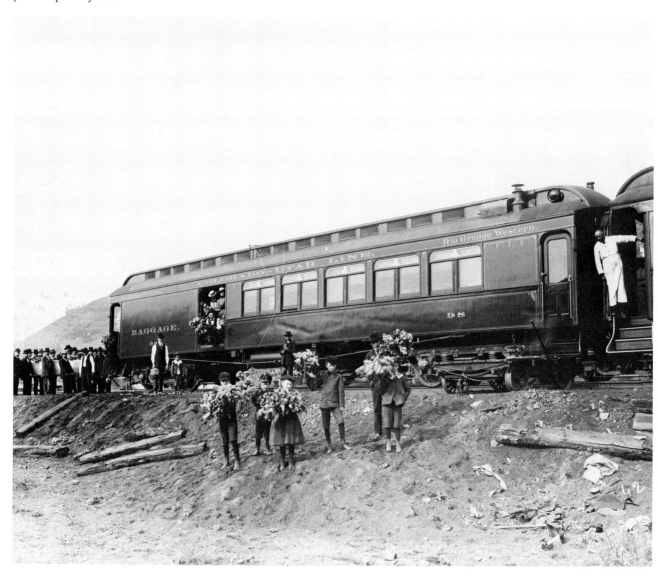

36. *Winter Quarters Mining Town, Winter Quarters, Utah, 1900. A view of Winter Quarters, looking down the canyon toward Scofield, includes a few of the survivors of nearly two hundred miners killed on May Day, 1900, in the number four mine of the Pleasant Valley Coal Company. Winter Quarters is now a ghost town.*

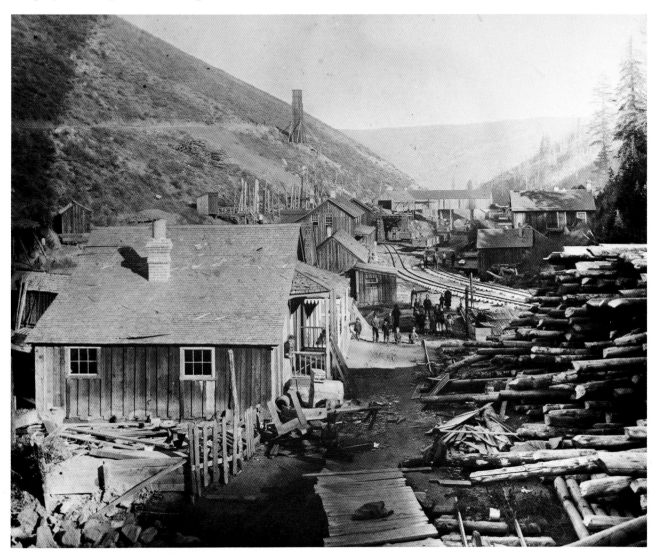

37. *Caskets at Wasatch Store, Winter Quarters, Utah, 1900. Caskets were shipped from Salt Lake City and other western cities to the Wasatch Store at Winter Quarters; they were then distributed to the families of the mine victims.*

38. *Bodies at Scofield Depot, Scofield, Utah, 1900. Coffins at the Scofield Train Depot await shipment to various Utah communities and other states where the victims were to be buried.*

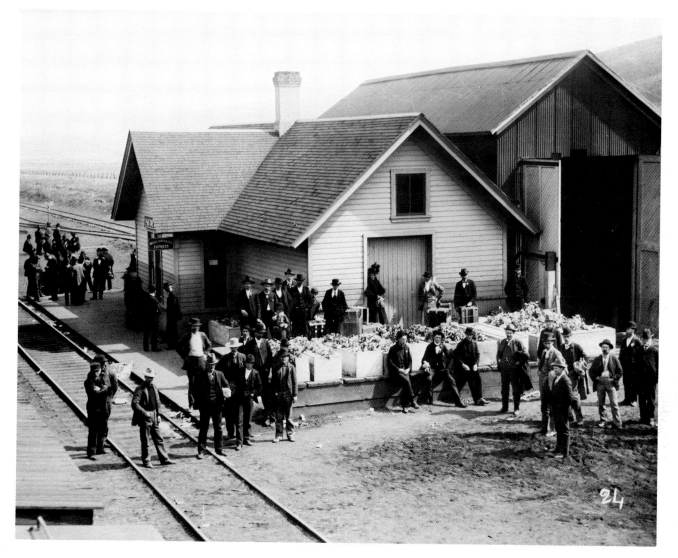

39. *Burial Services at Scofield Cemetery, Scofield, Utah, 1900. One hundred and fifty men were buried in the rocky hillside of the Scofield Cemetery. The tragedy left 107 widows and 268 fatherless children.*

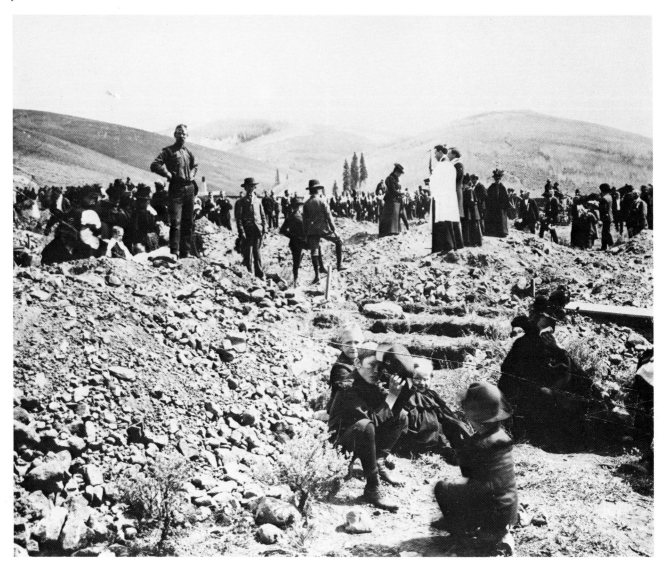

40. *Coffins of Disaster Victims at Knights of Pythias Hall, Scofield, Utah, 1900. Every public building was used to accommodate the bodies of the dead miners in order to prepare them for burial.*

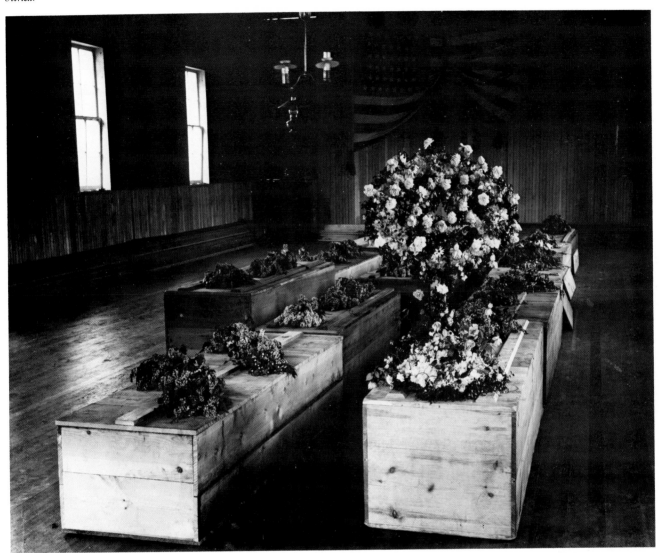

And Life Goes On

41. *Peoples Co-operative Mercantile Institution, Lehi, Utah, ca. 1885. Anderson stopped his photo gallery often at the local co-ops while traveling from Salt Lake City to southern Utah. Built in 1878, the Lehi store is representative of the efforts initiated by the Mormon church in 1868 to promote industry. To prevent monopoly the articles of incorporation of the institutions prevented any person from holding more than $200 in stock.*

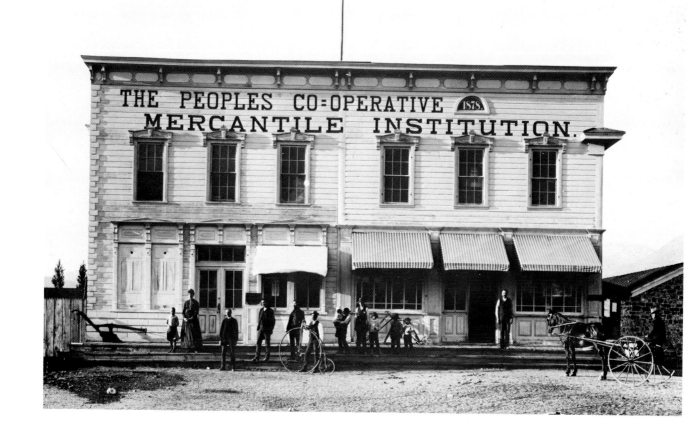

42. Martenes Anderson's Blacksmith Shop, Aurora, Utah, 1894. A Sevier County farmer, George Holdoway, prepares to have his white horse shod by Martenes Anderson, shown at left with his small son, Ralph. Anderson (1862–1938) learned to shoe horses while serving in the U.S. Cavalry. Approaching the small blacksmith shop with its wooden chimney is Eurastus Anderson, a brother.

43. *Otter Post Office, Angle, Utah, 1896. English-born Isaac Wagstaff first settled in American Fork, Utah, but then took his wife and five children to Piute County to be a rancher and postmaster at Otter, a remote outpost east of Circleville, the birth place of Butch Cassidy. The high altitude was harmful to his wife's health and the family returned to American Fork in 1897, where she died. William, the oldest son, is on the fence and Frank, the youngest son, is by the dog.*

44. Salina Salt Company, Salina, Utah, 1896. The salt, mostly in rock form, is mined from natural underground deposits found under the alfalfa fields of Redmond, an adjacent town. This illustration shows sacks of salt produced by evaporating water from a brine solution.

45. *Jex and Sons Broom Factory, Spanish Fork, Utah, 1896. Anderson recorded another home industry in the neighboring town of Spanish Fork. William Jex, standing at far right, supervises work done even by the children of the family. The cockatoo was brought from New Zealand where one of the sons had served a mission.*

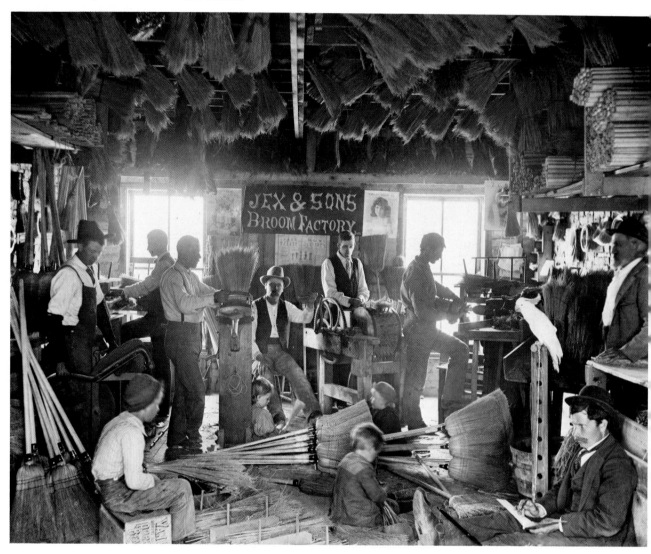

46. *Drug Store, Salina, Utah, 1896. The village sheriff and other Salina residents bask in the early spring sunlight at Percy Candland's Drug Store, which also housed the post office.*

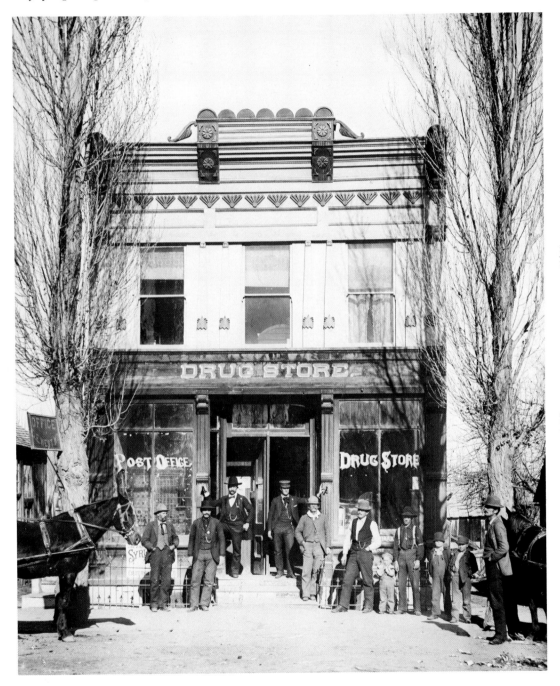

47. *Silkworm Industry, Springville, Utah, 1896. Mary Catherine Streeper Dougall, shown at left with fan, was instrumental in establishing the sericulture industry in Springville in 1896, prompted by an earlier plan of Brigham Young. Although a superior grade of silk was produced, the venture soon failed because the climate in Utah was not suitable for mulberry trees.*

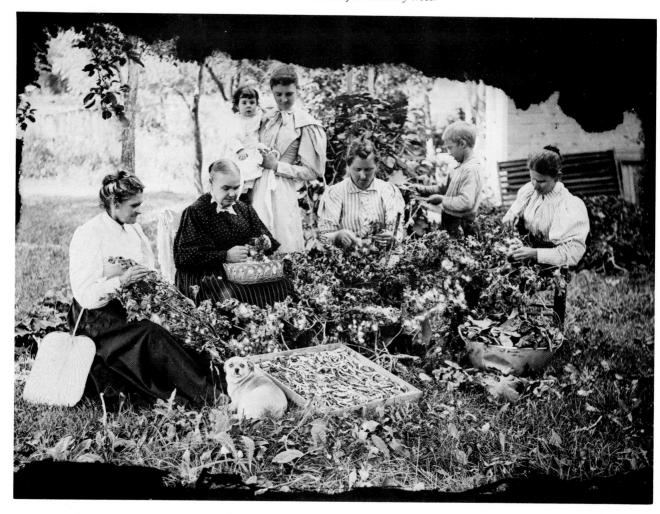

*48. Lewis Perry Threshing Crew, Mapleton, Utah, ca. 1898. Amos B. Warren, with the
whip, keeps the horses in motion to power an early threshing machine. Lewis R. Perry, foreman
of the crew, stands beyond Warren against the distant Springville mountains.*

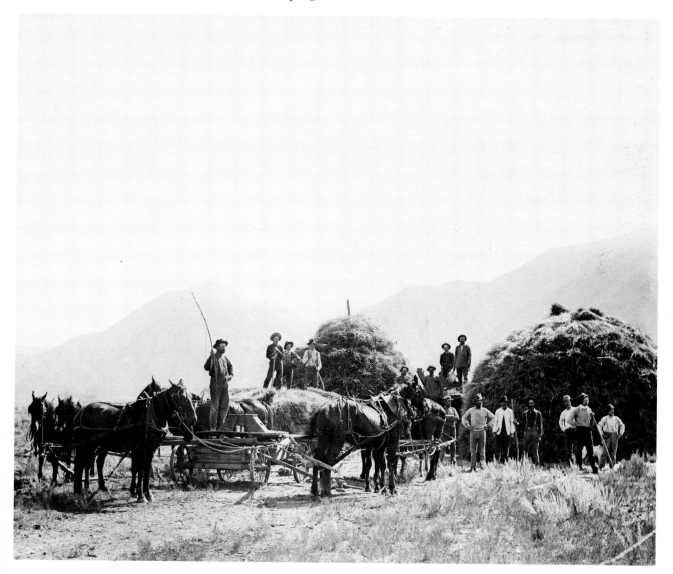

49. *Dr. Samuel H. Allen Residence, Provo, Utah, 1898. Dr. Allen, who was Anderson's brother-in-law, built this mansion in 1896. Anderson's wife, her parents, Mr. and Mrs. John Lowry (near steps) and the Lowry sisters with their husbands join together on a holiday. The house was later owned by various well-known public officials, among them Mormon Apostle John Taylor, who kept one of his polygamist wives there.*

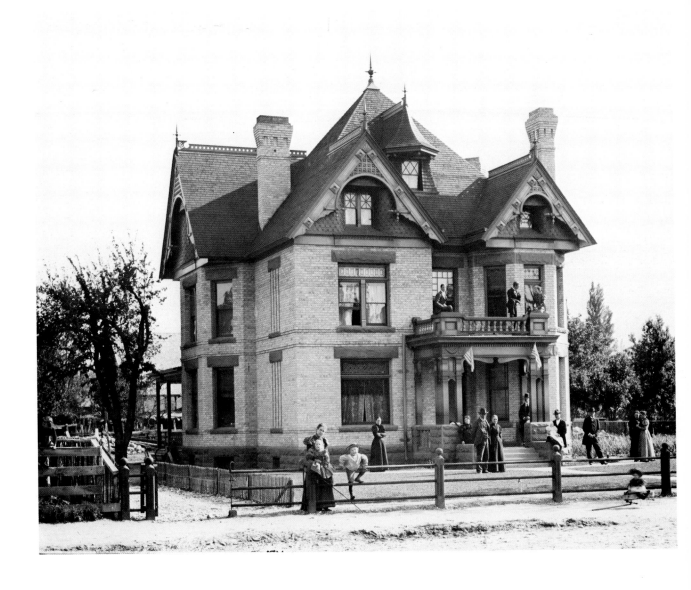

50. *Christian Otteson Children and Cows, Huntington, Utah, 1898. All the children assisted with the chores. Girls and housewives were often expected to take care of the milking. Otteson crossed over the mountains from Sanpete County on foot to file on a defaulted 160-acre claim in 1879. During the summer he and his older brother built a small log cabin and dugout, after planting the crops. In the fall they stored their harvest and walked back to Fountain Green for the winter.*

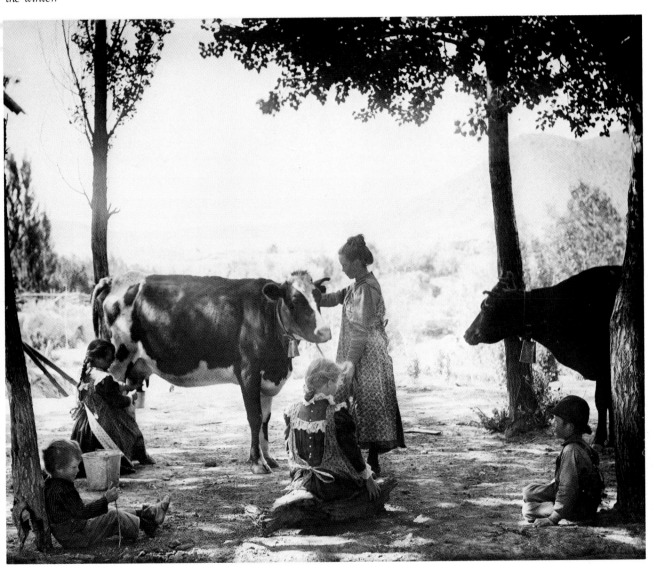

51. *Mrs. Bird's Grave, Springville, Utah, n.d. An unidentified mourner at the Springville City cemetery kneels at the graveside of either Emeline Crandall Bird (1824–1898) or her sister Laura Crandall Bird (1828–1905), the wives of Richard Bird, early pioneer settler of Springville.*

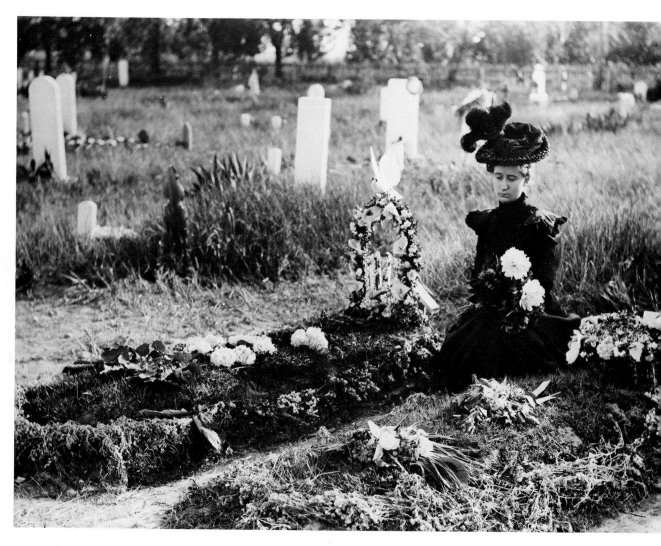

52. *The Return of Spanish-American War Veterans, Springville, Utah, 1899. Anderson delivered one of the patriotic speeches at a going away reception for the Springville volunteers. He was on hand to photograph the veterans' triumphant return in August, 1899.*

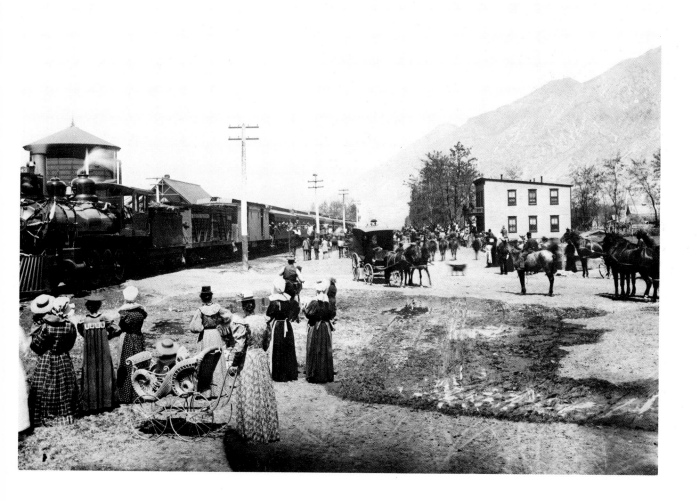

53. *McMullin Grading Crew, Sunnyside, Utah, 1899. In 1899 the Carbon County Railway constructed seventeen miles of standard-gauge track from Mounds to Sunnyside. The McMullin grading crew prepared the roadbed for the tracks leading to the coal fields at Sunnyside, twenty miles east of Price, Utah.*

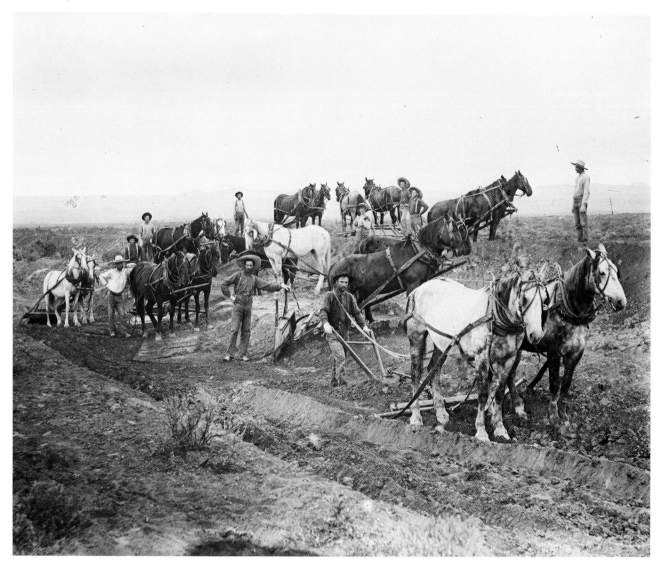

54. *Springville Sugar Beet Factory and Silage Pit, Springville, Utah, 1900. Utah became one of the first states successfully to manufacture refined sugar from sugar beets. Pulp or silage—a by-product of the process—is loaded from the pit to be fed to livestock.*

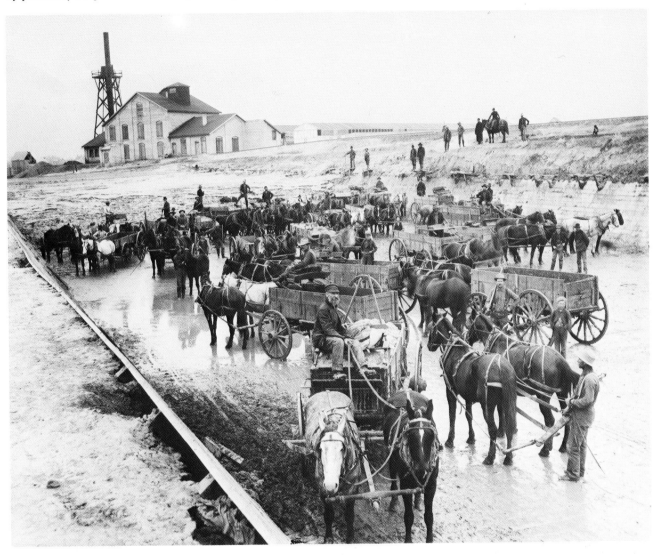

55. *Scofield School, Scofield, Utah, ca. 1900. In a patriotic assembly, possibly to celebrate Washington's birthday, these Scofield students join hands in a ring dance in front of their school building. Many would be fatherless in a few months because of the mine disaster.*

56. *Ether Blanchard Farm, Mapleton, Utah, 1902. Most boys like Achilles (Chilles) Blanchard, at right, were kept out of school to assist with farm work. Ether insisted upon harvesting the hay and grain on his thirteen acres with the outmoded cradle scythe. The grain shocks were hand tied with cords of wheat stalks.*

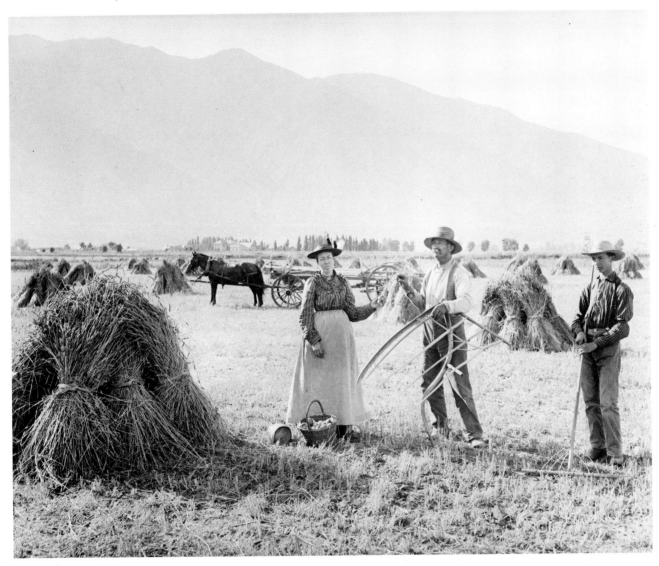

57. *Eugene Schuman's Bridge Crew, Hales, Utah, 1903.* Anderson accepted on-call assignments from the Rio Grande Western Railway Company to document its western expansion into Utah. Railroad workmen and their families lived in the box cars that could be located on a sidetrack close to their work on the iron bridges.

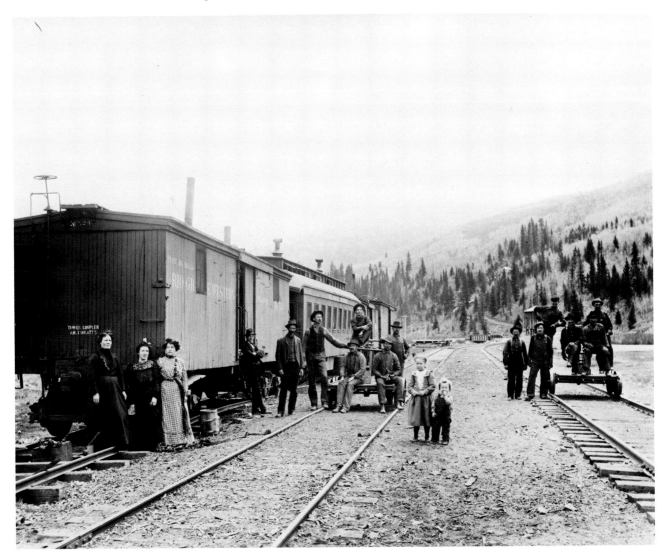

58. *George Naylor Residence, Salt Lake City, Utah, 1903. With an 8-by-10 view camera Anderson could record countless details of the landlord's home, barnyard, and family. Perhaps the best genre sample shown here is the unusual grouping of mother, children, and lambs.*

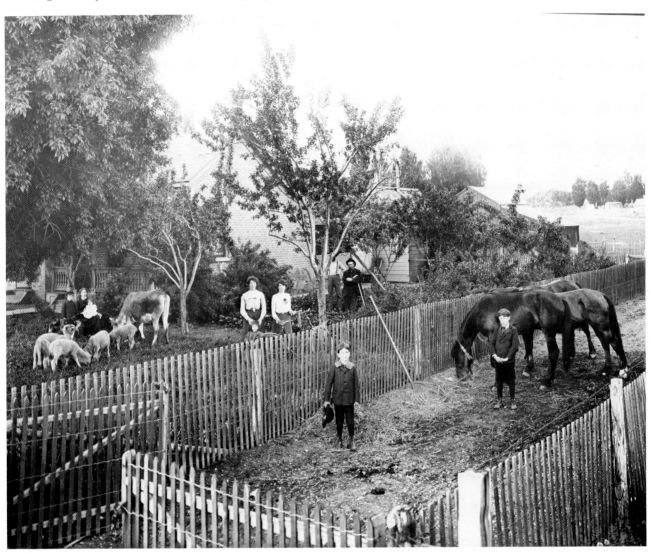

59. *RGW Railroad Reservoir near Helper, Utah, 1903. On a return trip to Springville from a railroad assignment, Anderson encountered damage from a flash flood down Price Canyon. In his diary he recorded: "Made view of men cleaning out reservoir, 8 feet of mud."*

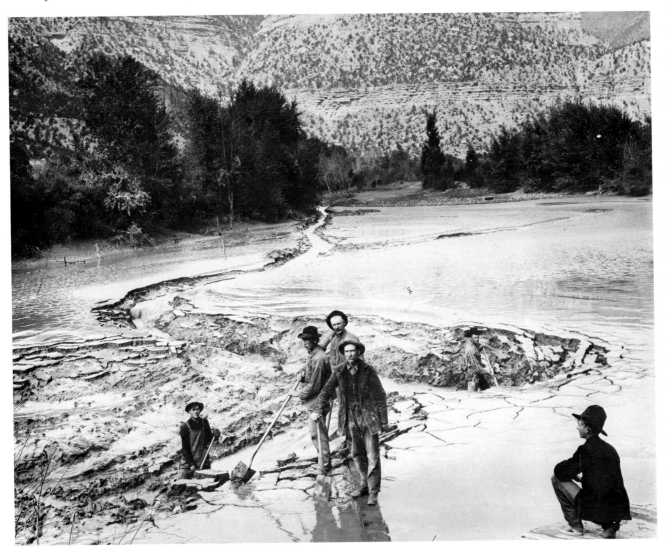

60. *Reunion Encampment, Payson, Utah, 1904. Bearded John Hubbard Noakes, in folding chair, and other Springville pioneers and Indian fighters gather with their families at the Black Hawk War Veterans Reunion at Payson in 1904. These annual reunions are still held in Utah even though all the veterans have passed away.*

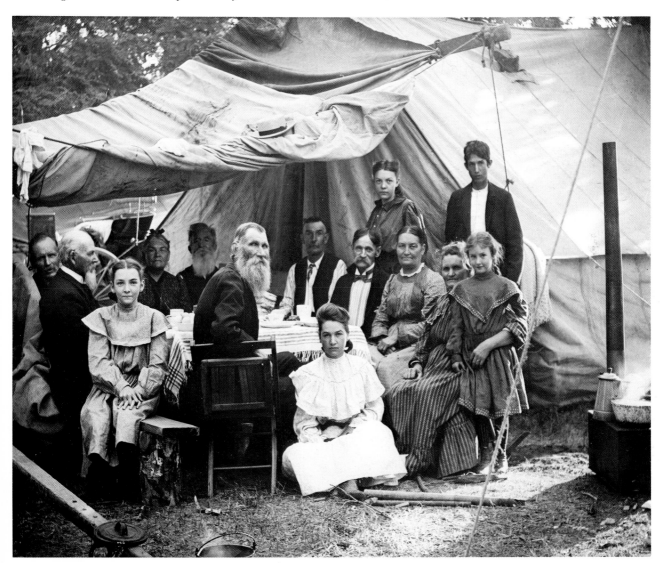

61. *Bromley Threshing Crew, American Fork, Utah, ca. 1904. In this harvest scene near the newly built American Fork Second Ward Church, farmer Niels Christensen, stands tall on the thresher while Willis M. Bromley, owner and engineer of the thresher (at the controls of the steam-powered tractor), provides the "horsepower"; others on the crew were a bagger, bundle cutter, feeders, and water boy. The unseen farmer's wife does the rest. She must provide an enormous noon meal for the crew who, like the thresher, never seem to get full.*

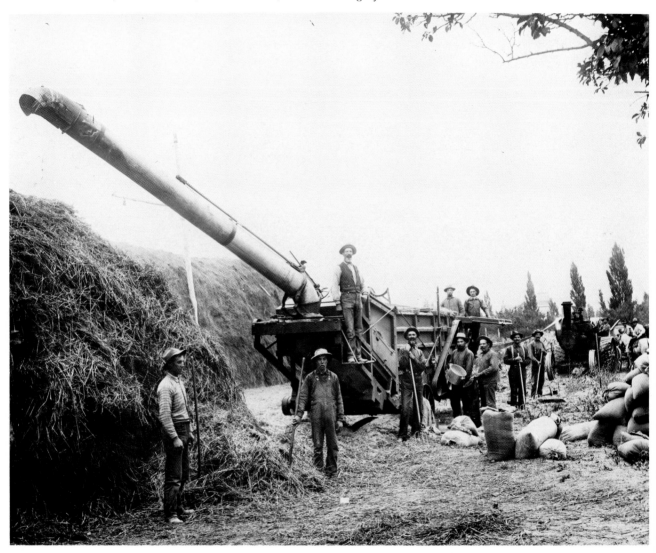

62. *Mapleton Church Fire, Mapleton, Utah, 1905. Anderson was on hand to record the quick efforts of the bucket brigade which carried water from an irrigation ditch to put out a fire at the Mapleton meetinghouse. William Tew recorded in his diary: "Today the church caught fire. Damage was estimated at $49.25."*

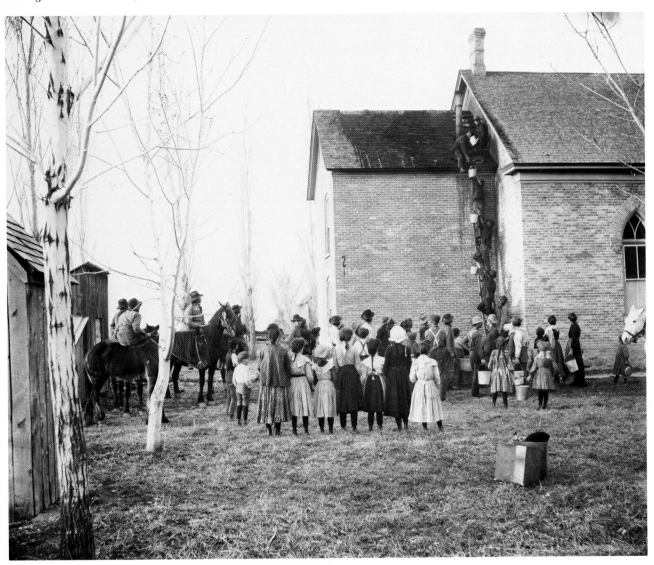

63. *Utah County Horse Show, Provo, Utah, 1906. When the automobile was not yet popular in western cities, a good horse was still man's best friend. Provo's Center Street is seen in the background.*

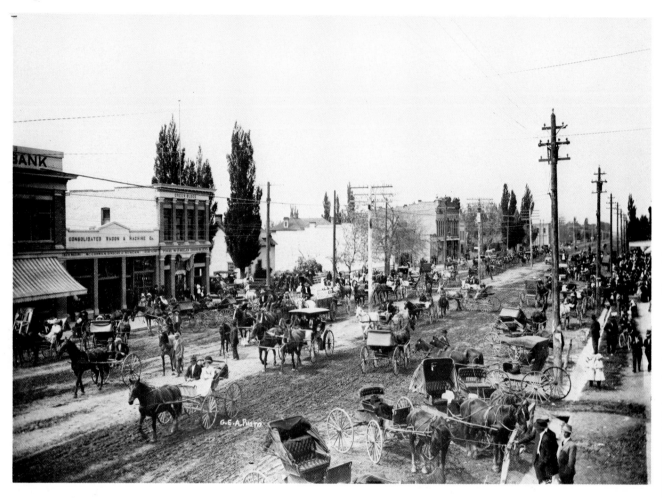

64. *Mathew Grant and Water Wagon, Salem, Utah, 1915. Although dressed a little strangely for the ride, Mathew Grant's cousin, Mattie Davis Miller, is hitching a ride to the construction site of the Strawberry Canal where both her husband and Mathew work.*

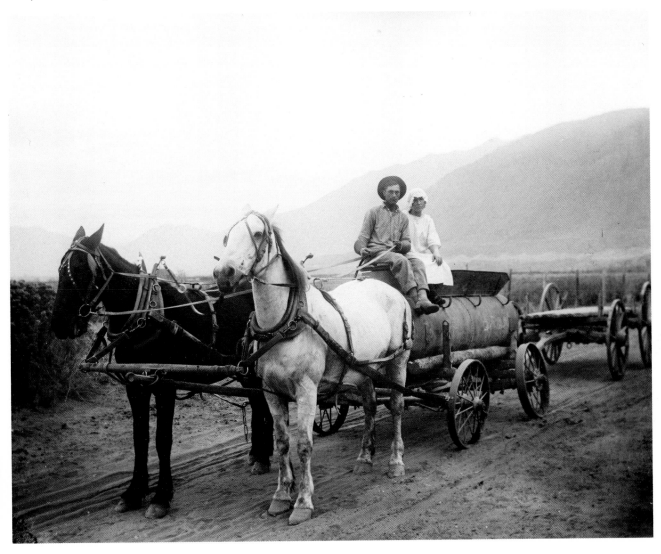

65. *Sugar Cane Mill of Moses Beckstead, Spanish Fork, Utah, 1915. The operation of one of the few remaining horse-powered sugar cane mills was documented by Anderson in 1915. Juice was collected from the cane stalks as they were crushed between the rollers of the crude machine. The syrup was then boiled in vats in the nearby sheds to produce the sweet molasses. Moses Beckstead stands at right with his crutch.*

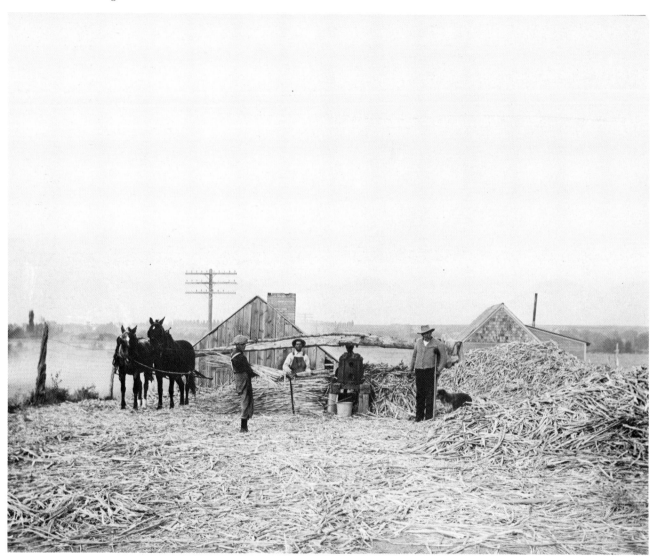

66. *I. R. Pierce and Melons, Salem, Utah, 1920. Isaac Riley Pierce (1883–1942) was known throughout Utah County for the prize watermelons grown on his farm in Salem, Utah. The word "Pic," scratched on the rind of the largest melon in the foreground, meant that it was the best of the crop.*

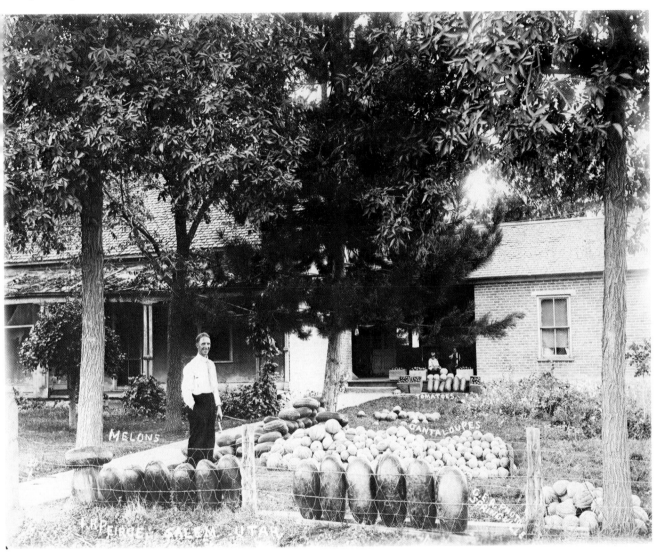

67. *John Willson's Boys, Lawrence, Utah, ca. 1905. Anderson undoubtedly could not resist this roadside scene.*

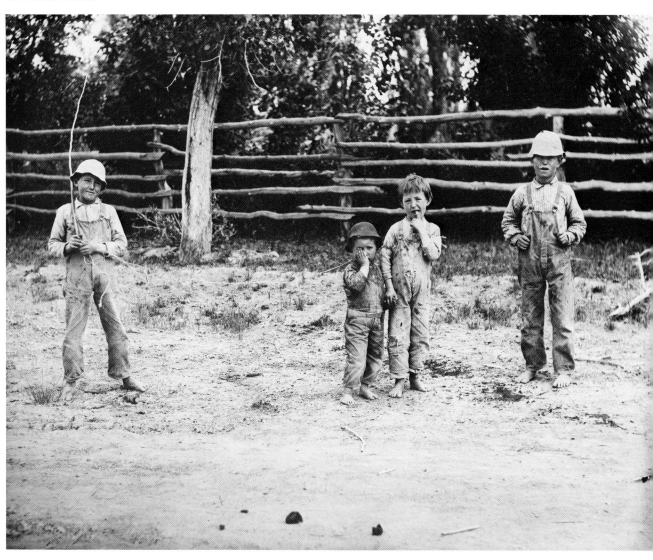

A Half-Remembered World

68. *Tent Gallery Portrait of Brockbank Family, Spanish Fork, Utah, 1888. This contact print clearly shows how Anderson recorded the name of the Joshua Brockbank family, the city, the number of prints to be made, and the file number by etching the emulsion side of the glass-plate negative. Only eight of the family's thirteen children are shown.*

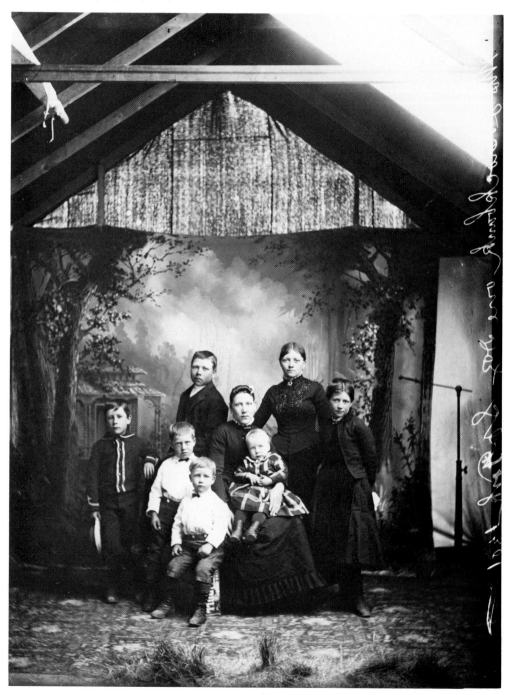

69. *Provo Boat Club Lightweight Crew, Provo, Utah, 1890. These Provo businessmen—Coray, Duesenberry, Buckly, and Knowlden—ordered two papershell crew boats from New York and won competitions against Salt Lake City crews in 1890 and 1891. An appropriately painted backdrop completed this well-planned composition.*

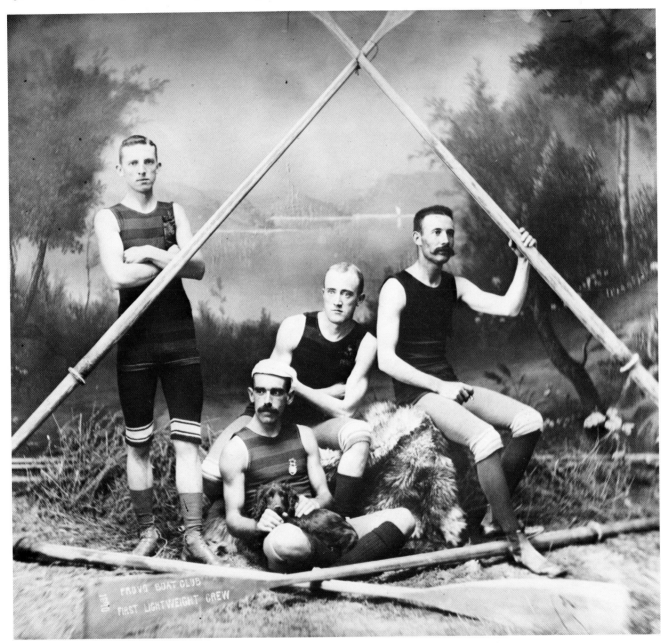

70. *George Carter Family, Fountain Green, Utah, 1893. At the top are Malinda and her grandfather, Rueban Carter; at the bottom are Elmer; his mother, Ellen Jones Carter; Ada (holding the doll); Loretta; grandmother Sarah Ann Jackson Carter; and George Carter (1850–1921), a devout Mormon who was born in England.*

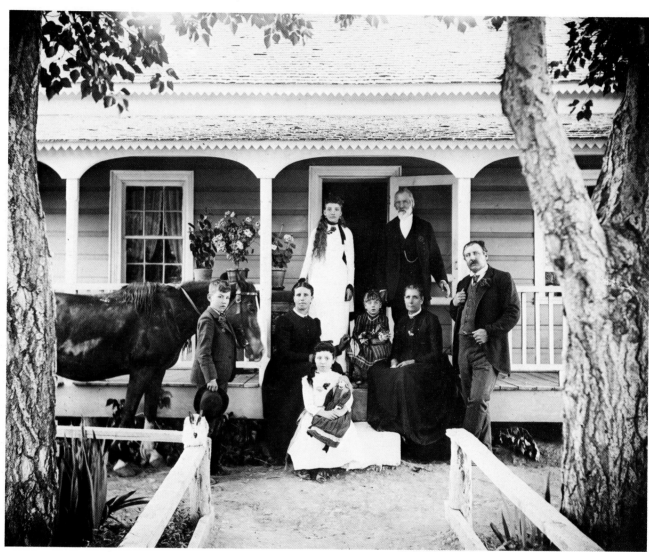

71. *Mail Call at Santaquin Post Office, Santaquin, Utah, 1893. In spite of slow shutter speeds, Anderson somehow directed his subjects to hold natural poses. The postmaster, James Eckersley (man with vest near doorway), also distributed welfare goods to the needy from supplies donated to the Mormon church.*

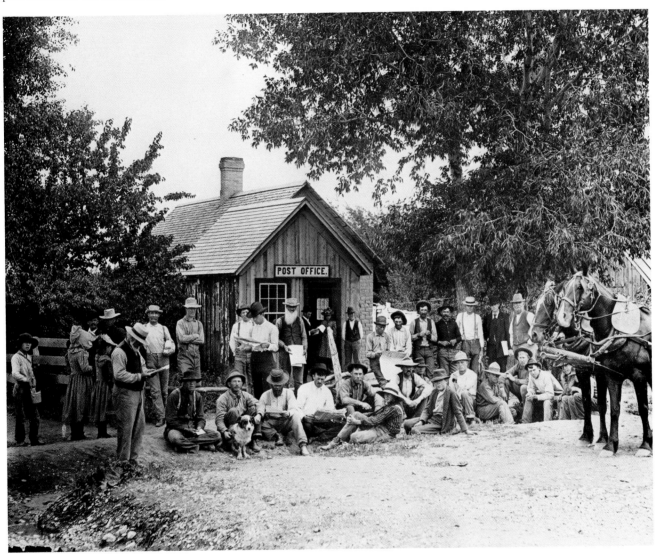

72. *Cove School Group, Sevier, Utah, ca. 1896. This time Anderson's usual skill at relaxing people somehow failed. The earnest child who holds her slate and completes a pyramid design in the center seems to hope that everything will turn out all right.*

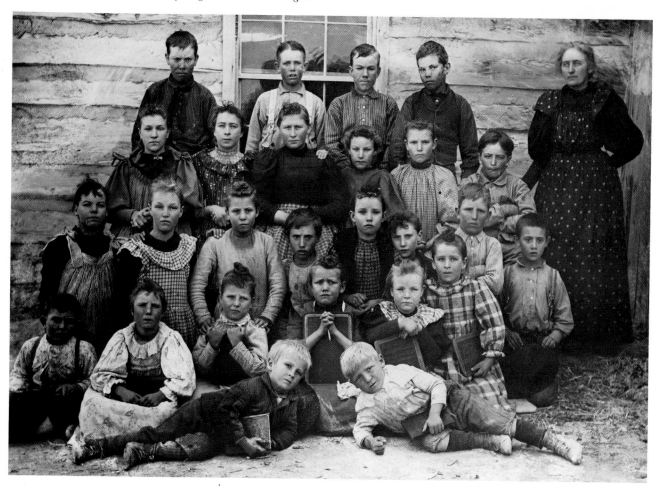

73. *Vest Perry's Alpine Home, 1896. Like hundreds of Springville men who left the farm to earn high wages working for the railroads, John Sylvester Perry took his family with him while cutting timber for railroad ties. Family records showing the ages of the children, especially the twin boys, Jesse and Jasper, were most helpful in identifying and dating this early picture.*

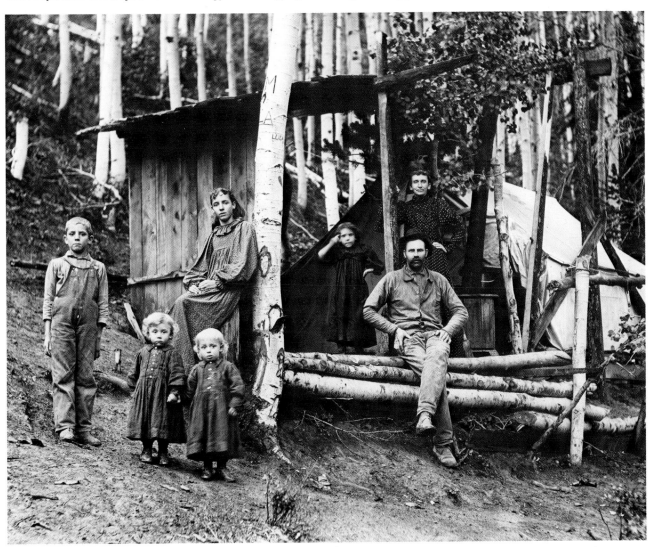

74. Blacksmith Shop, Silver City, Utah, ca. 1890–1900. Settled in 1870, the town had a "billiard saloon, blacksmith shop, grog hole, some tents, several drunks, a free fight, water some miles off, a hole down 90 feet hunting a spring without success, and any number of rich or imaginary rich lodes in the neighborhood. The owners are all poor, and the poor men work for them." Today, Silver City is a ghost town.

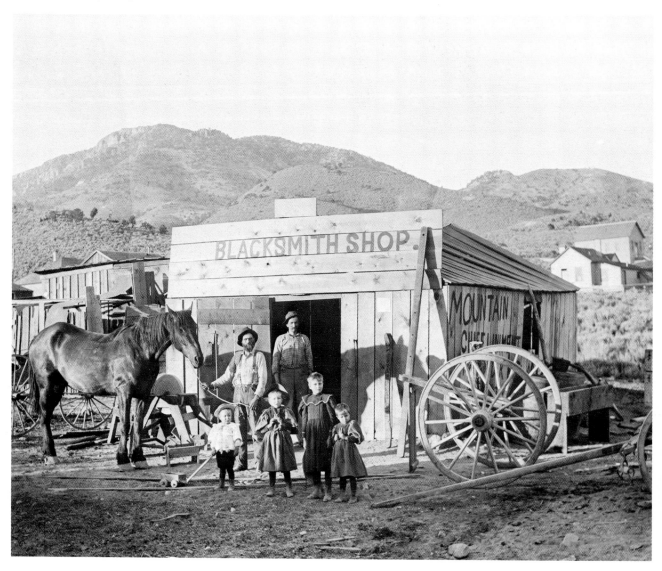

75. *Coal Miners, Castle Gate, Utah, ca. 1897. Veteran miners remember this equipment—the number one mine fan house, powered by steam which also generated electricity; the oil wick lamps; and the double-layered lunch pails with water on the bottom and food on top. Near this spot stood the miners' homes and the RGW depot where Butch Cassidy robbed the mine payroll in 1897.*

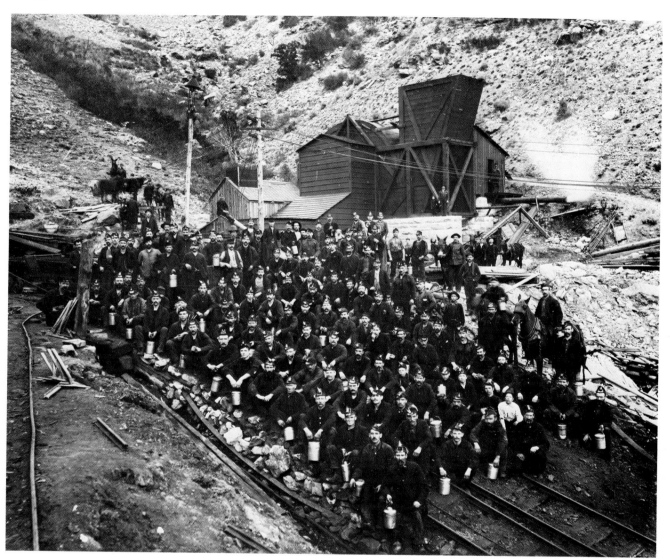

76. *Pioneers of 1847, Salt Lake City, Utah, 1897. Told he could not succeed by other professionals, Anderson grouped these pioneers on Temple Square and attempted to show each face of those who had arrived in Utah some fifty years earlier.*

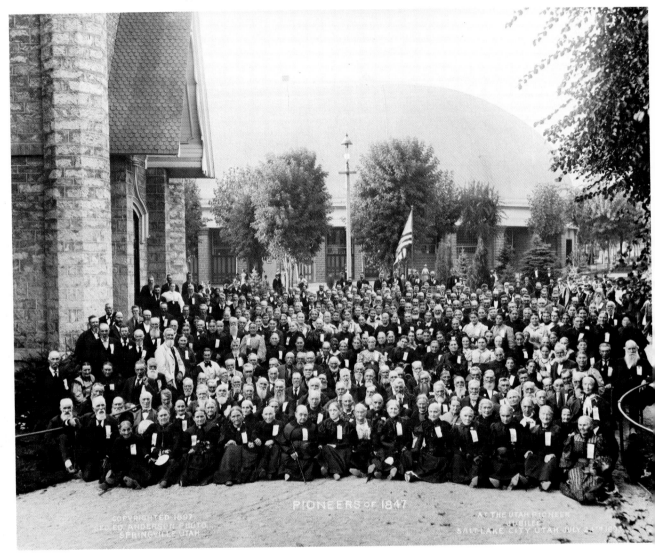

77. *William Jex Family Reunion, Spanish Fork, Utah, 1899. In Mormon Country (1942), Wallace Stegner talks about the hundreds of grandchildren and great-grandchildren resulting from William Jex's marriage to Eliza Goodson. In the background is the Jex home on south Main Street in Spanish Fork. The broom factory was housed in the frame building to the right.*

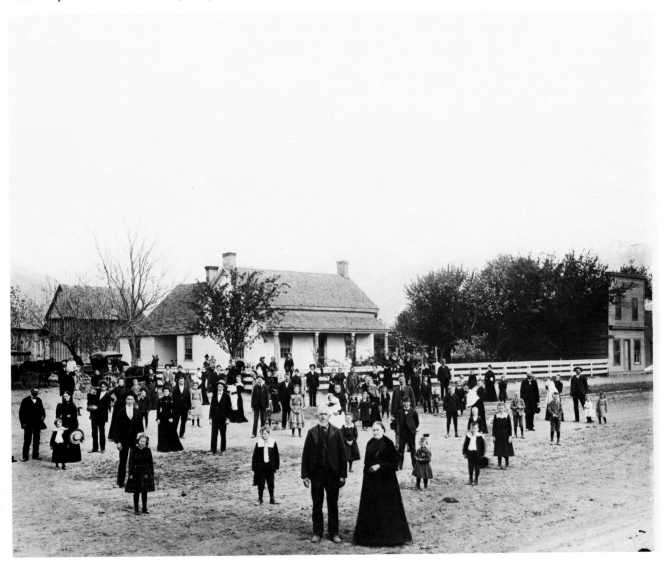

78. *Thomas Potter's Smithshop, Scofield, Utah, ca. 1899. A less pretentious family gathering in front of this crude mining town blacksmith shop shows Thomas Potter, his wife, and their children and grandchildren.*

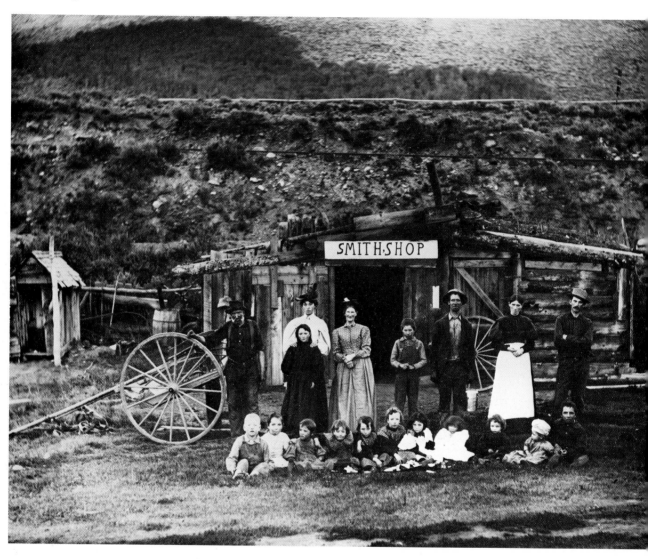

79. *Stanley Gardner's Section Crew, Indianola, Utah, 1900. Twenty-one-year-old Stanley Gardner, at left, stands apart from his section crew. All have left their nearby ranches to work for the RGW Railway. Three years later Gardner was killed when his handcar ran into an approaching locomotive. William White, shown next to Gardner, married his widow and raised his two children.*

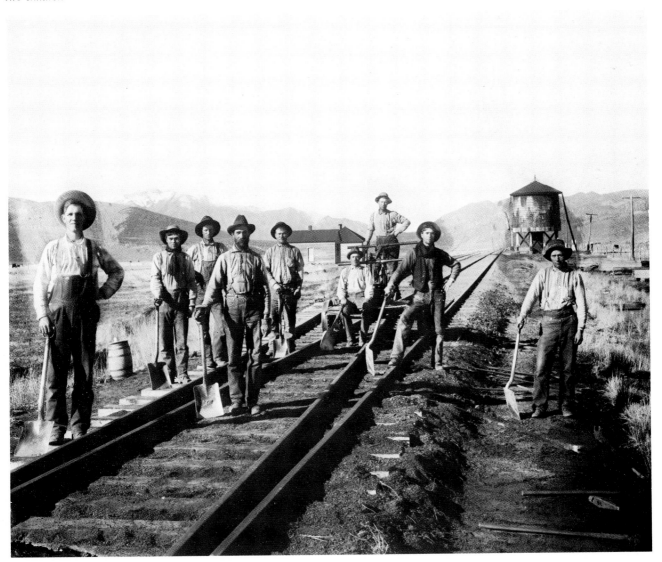

80. *Amos Sweet Warren and Indians, Springville, Utah, 1900. Warren was one of the original settlers of Springville in 1850; he was a blacksmith, beekeeper, and Indian interpreter, and Indians often camped on his lot in Springville. Shown here in costume, Warren and his young friend have participated in Independence Day activities in Springville.*

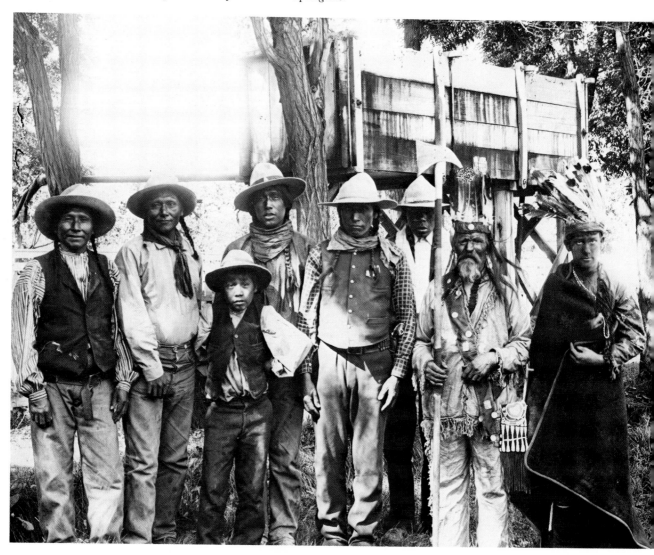

81. *Charles Barney Family, Lake Shore, Utah, 1900. From this humble beginning Charles Barney, at right, developed the fertile river bottomlands at Lake Shore, Utah, into a prosperous farm. Sugar beets became the best cash crop for Barney and other farmers in that area.*

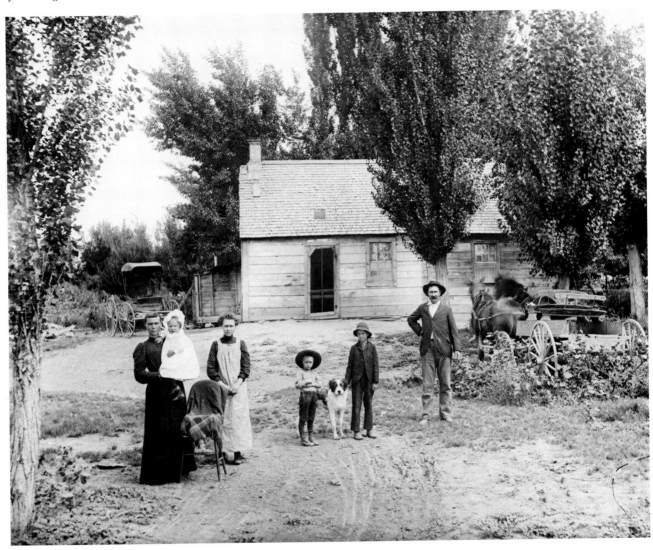

82. *Sons of Aaron Johnson, Jr., Springville, Utah, 1900. The talented grandsons of Springville's first colonizer and bishop, Aaron Johnson, were some of Springville's best actors, musicians, and painters. Their father, Johnson, Jr., and his brothers built the first opera house in Springville. Byran Johnson, leaning on the central post, was killed in the Castle Gate Mine in 1924.*

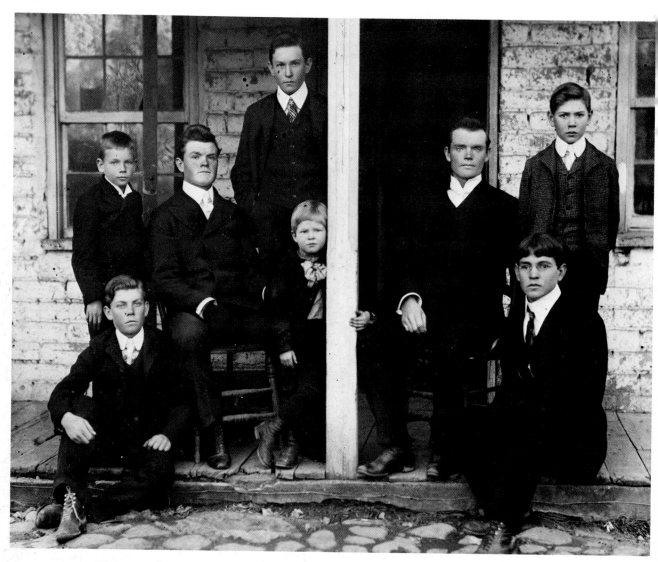

83. *Paiute Indians at Kanosh, Utah, 1901. Although Anderson concentrated his efforts on Mormon settlements and church subjects, his travels brought him to this band of Paiute Indians at Kanosh (named after an Indian chief) Indian Reservation. The mounted Indians are returning from a successful deer hunt.*

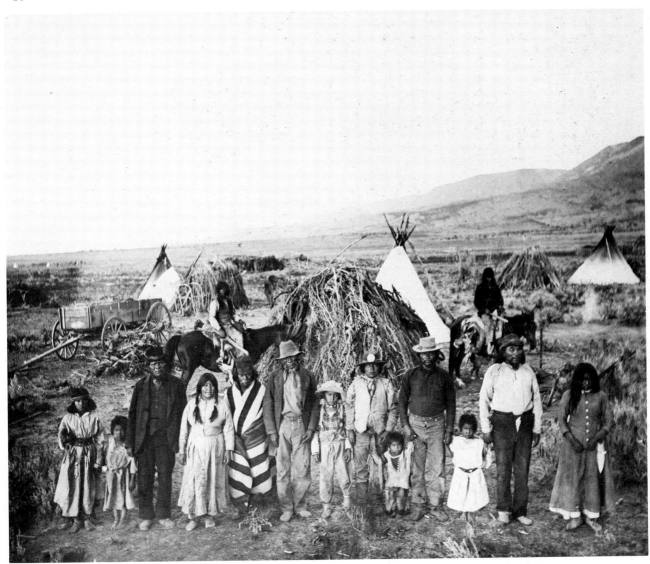

84. *Graduates of the Eighth Grade, Mapleton, Utah, 1901. Graduation exercises of this period were something special—engraved invitations, handlettered diplomas, elegant dresses, and a beautiful portrait to commemorate the occasion. Horace Manwaring and his teacher, John Israel Hayes (center), were very much alone in this bevy of girls.*

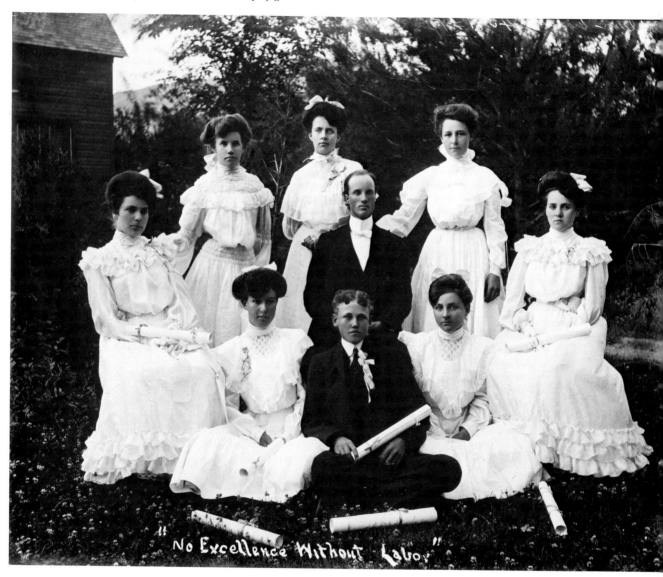

"No Excellence Without Labor"

85. *Spring City School Group, Spring City, Utah, 1902. In the shadow of their new school, these students are photographed by Anderson from an upstairs window to catch the light on each upturned face. Olive Acord preserves order among her first graders while Principal John S. Blain, in the opposite upper corner, keeps the eighth graders in check.*

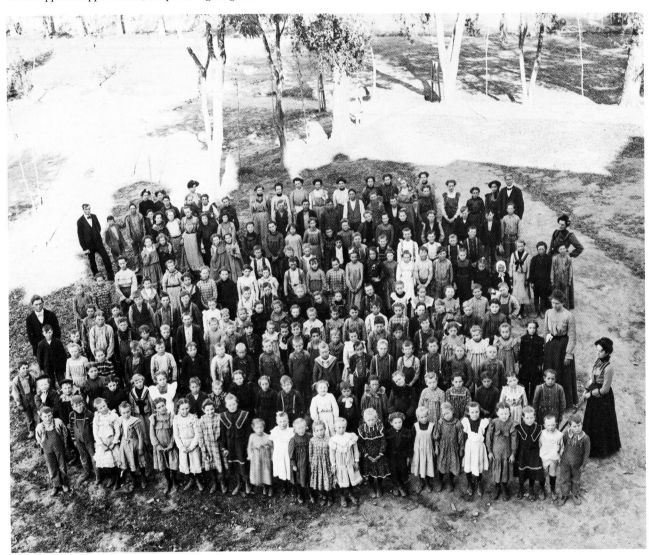

86. *Indian War Veterans at Saltair, Salt Lake City, Utah, 1902. The ornate pavilion at Saltair with its huge ballroom was an ideal gathering place for the annual reunion of the Indian War Veterans. Many members of the group were from Springville.*

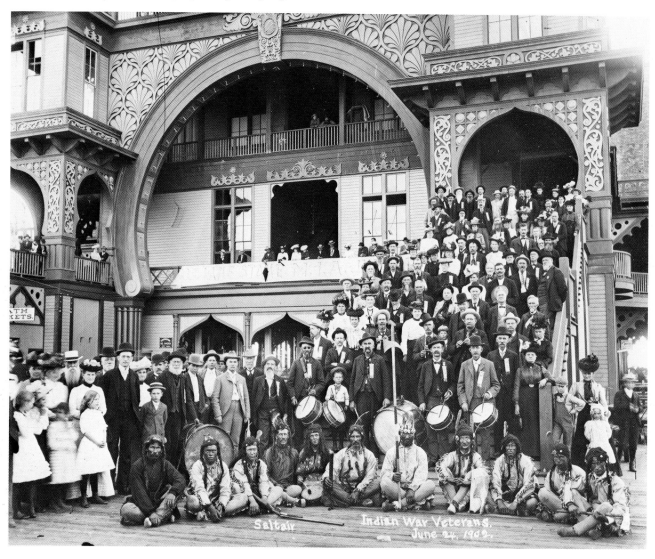

87. *Joe Barton Family in Box Car Home, Price, Utah, 1902. Anderson's grim portrait of this railroad hand and his family rivals the later work of Dorothea Lange, who gained fame with her photographs of deprived Americans during the Depression.*

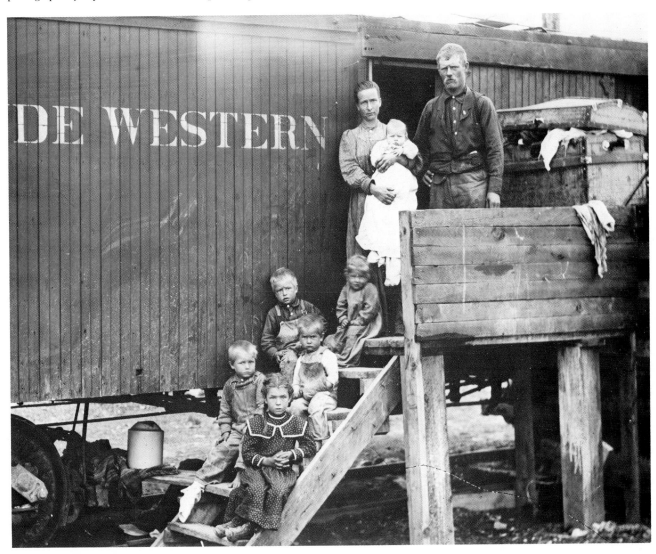

88. *Springville's Old Folks, Springville, Utah, ca. 1906. Anderson's interest in historical sub-jects prompted him to make this portrait of some of Springville's oldest residents and early pio-neers. Moroni Miner, at left on the back row, lived to be 100 years old.*

89. *Sumsion Brothers at Train Depot, Springville, Utah, 1915. Among the travelers waiting for the northbound Denver and Rio Grande train are the Sumsion brothers in the foreground. LaCell, on the left, is going to Brigham Young University at Provo and Bert is leaving for a mission to Canada.*

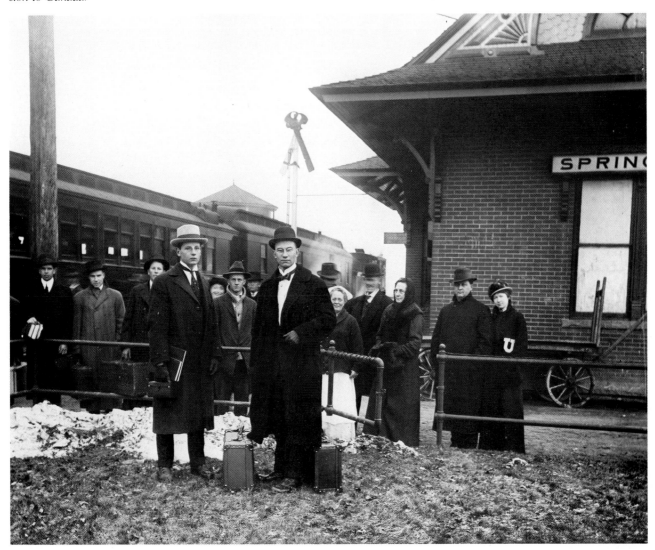

90. *Erastus Barney Family, Lake Shore, Utah, 1915. Erastus Barney, his wife, and his children relax after a day's work on their Lake Shore farm. Barney often produced thirty tons of sugar beets to an acre on his fertile land bordering the Spanish Fork River.*

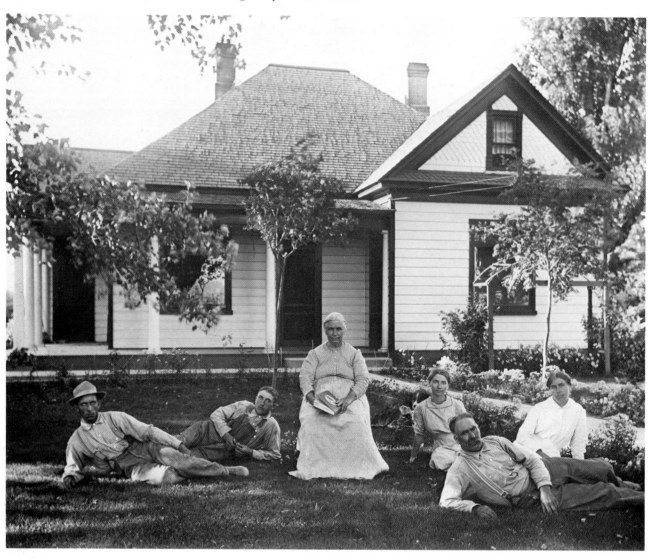

91. *Thomas Smith Family, Santaquin, Utah, 1916. Precisely balanced, the sober-faced Thomas Smith family poses in a doorway. The sturdy sons seem to be guarding the head of the household, who cannot be identified among the self-conscious faces.*

92. *A Special Song, "Catch the Sunshine," Lambs at Milbrook Farm, South Royalton, Vermont, 1912. While documenting Mormon history sites in Vermont, Anderson made this dramatic photograph which he intended to use as an illustration for a favorite Mormon hymn, "Catch the Sunshine."*

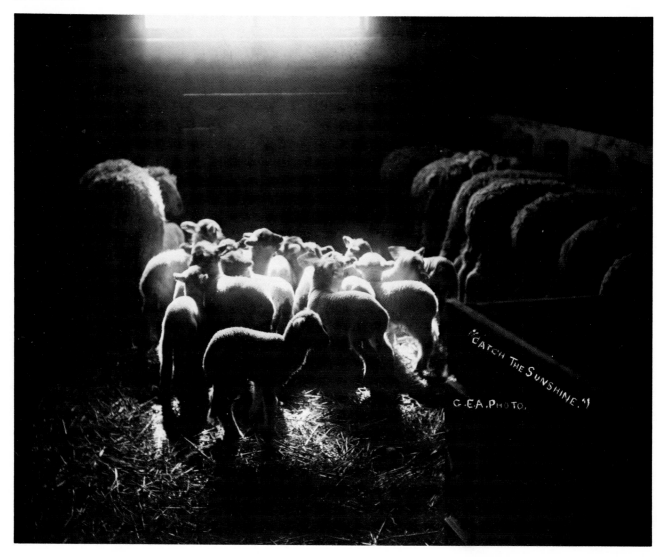

Everything Changes

93. *Manti Temple under Construction, Manti, Utah, 1886. Anderson's enthusiasm for documentary photography is evident in the dozens of exposures he made of the Manti Temple during the last two years of its construction. Built upon a prominent knoll, the edifice was made from oolite quarried from the same hillside.*

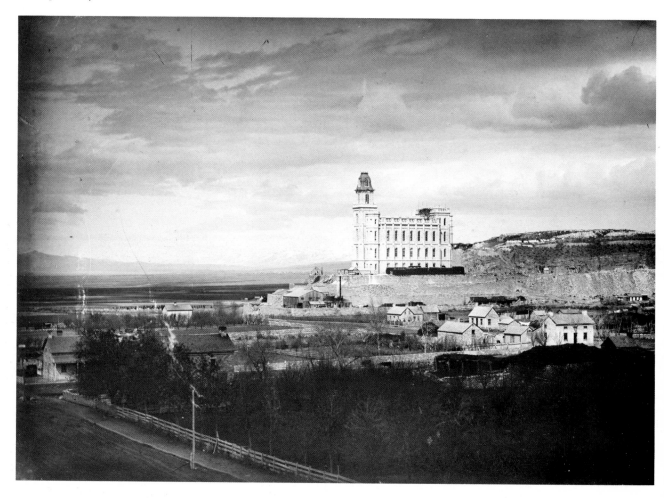

94. *Tinner Shop of H. J. Mortensen, Spanish Fork, Utah, ca. 1894. H. J. Mortensen, better known as "Tinker," is shown amid his metal products and fancy baby buggies. A Danish convert to Mormonism, Mortensen left his church and business to return unexpectedly to Denmark.*

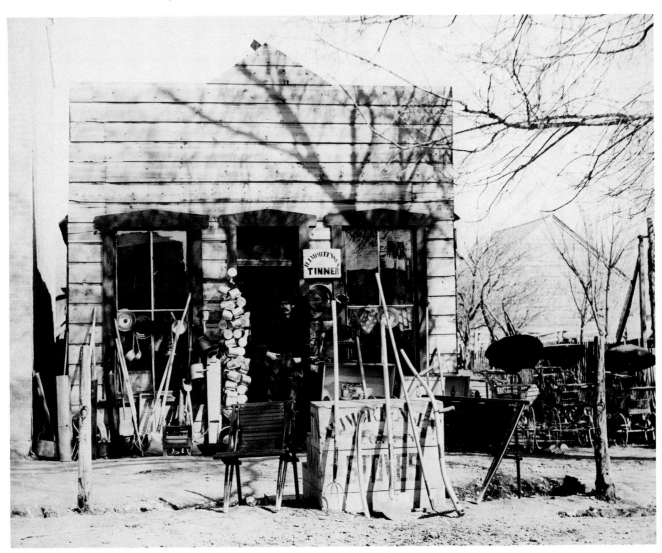

95. *Arrival of First Train in Richfield, Utah, 1896. Anderson was on hand to record the jubilant arrival of the Rio Grande Western's Number 2 engine with the first passenger service to Richfield in Sevier County.*

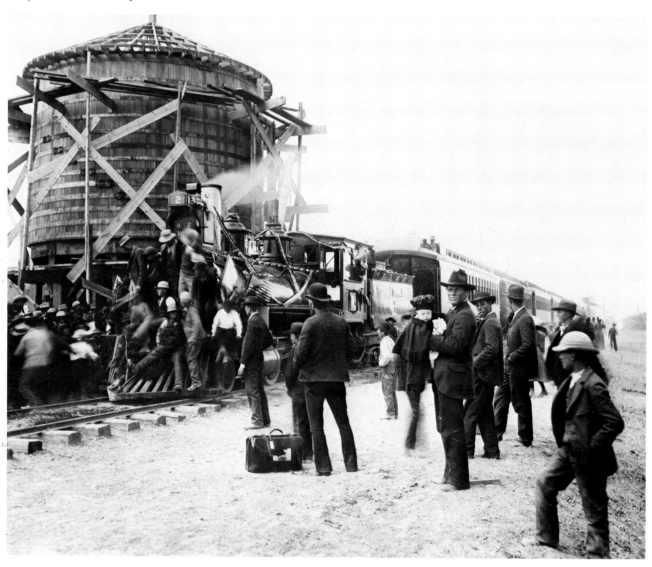

96. *Ercanbrack Ranch, Goshen, Utah, ca. 1898. This picturesque ranch, owned by William T. Ercanbrack (1840–1911) and later by his son, Otis, supplied much of the meat and vegetables for the mining town of Eureka, located in the mountains beyond. Presently known as the Wolfe Ranch, this homestead still displays the Lombardy Poplar trees, a species introduced by early Utah settlers.*

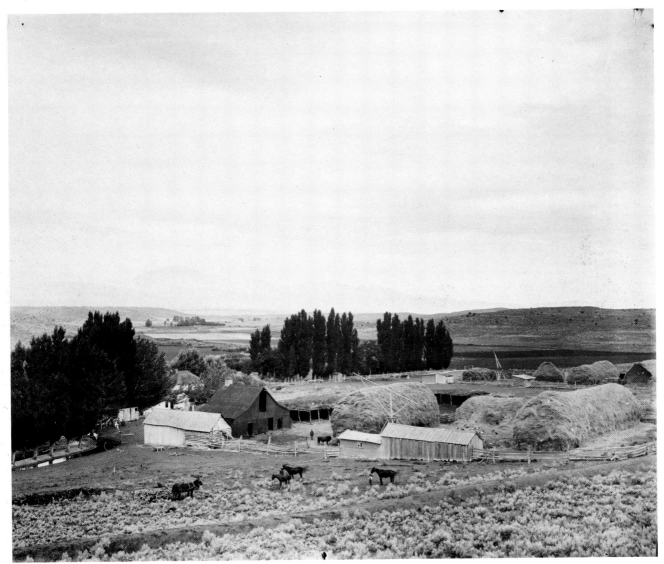

97. *Wesley Matson Residence, Mapleton, Utah, 1898. The house was built in 1894 by Aaron Wesley Matson, a young contractor who died before this picture was taken. Grandmother Sarah Waters and an adopted Maori daughter, Violet Moore (behind fence, center), came to live there and help Matson's young widow and children (shown at left).*

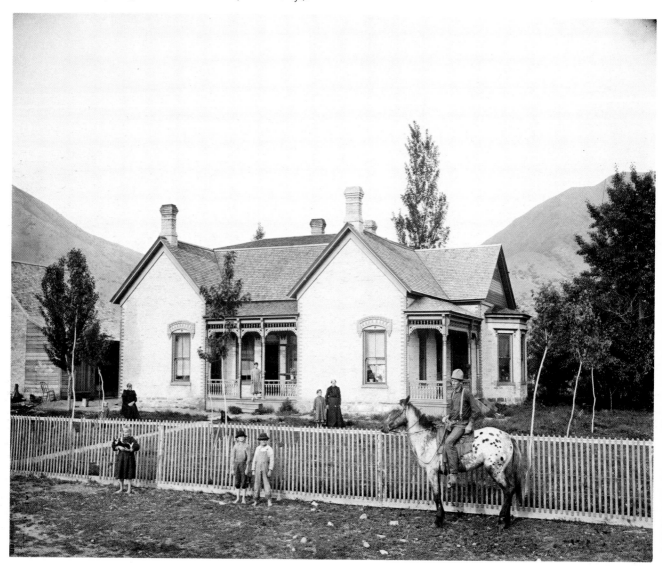

98. *Christian Otteson Farm, Huntington, Utah, 1898. The imposing home of Christian Otteson and the horse-drawn buggy at left seem out of place in the arid landscape of Emery County. Without the unique irrigation systems designed by the early pioneers to bring water from distant mountain watersheds, much of this area would have remained a wasteland.*

99. *Ira D. Lyman, Soldier Station via Price, Wellington, Utah, ca. 1899. Anderson's travels to the mining towns of Carbon County brought him to this remote outpost where stage coaches and freight wagons stopped on their way from Price to Vernal, Utah.*

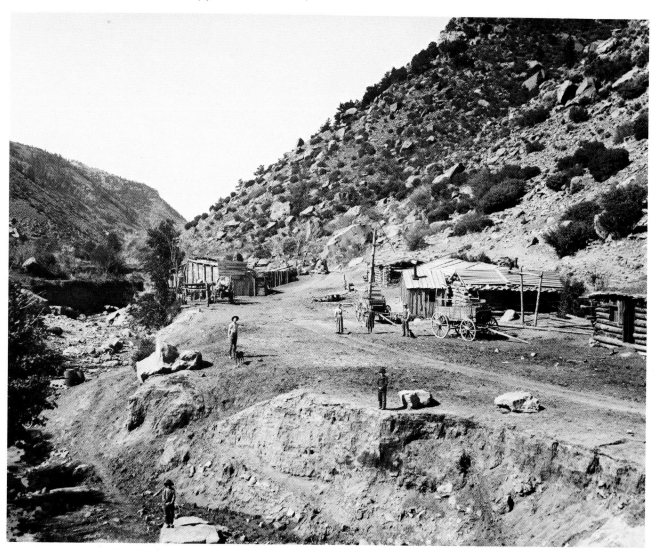

100. *Melvin Harmer, Spanish-American War Volunteer, Springville, Utah, ca. 1899. The pose is staged, but twenty-one-year-old Melvin Harmer of Springville, a volunteer in Troop C, would shortly begin military service in the Spanish-American War of 1899. He later became a Springville police officer.*

101. *Sunnyside Town, Utah, 1899. Sunnyside is a classic example of a company town. Earlier dugouts and offices lie at the foot of the hill while the new houses and buildings continue to rise around them.*

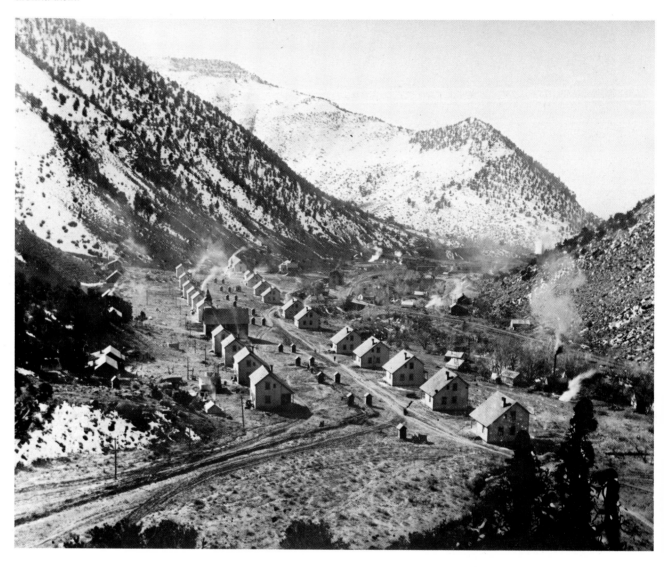

102. *Big Springs Ranch, Sunnyside, Utah, ca. 1899. The big springs about seven miles west of Sunnyside became an oasis for early settlers. The first to develop the ranch was a mysterious Englishman, Lord Scott Elliot. He built a fourteen-room house near the abundant mountain springs. When severe winters, drought, and falling livestock prices crumbled his empire, he left as mysteriously as he had come.*

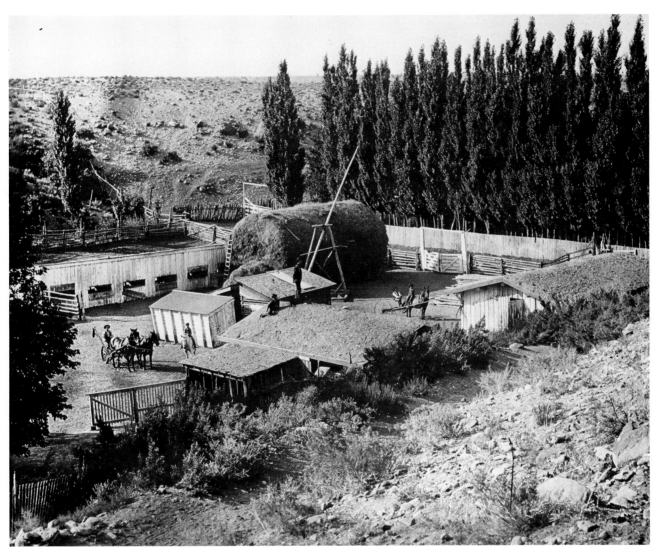

103. *Building a Mining Town, Clear Creek, Utah, 1899. Near Scofield the Carbon County Railway, later sold to Rio Grande Western, constructed five miles of standard-gauge tracks to the rich coal deposits at Coal Creek. When the earliest narrow-gauge line into the mines at Scofield, the Pleasant Valley Railroad, went broke its builder, Milan Packard, paid off his workers with cloth from his General Mercantile Store in Springville, and his railway became known as the "Calico Road."*

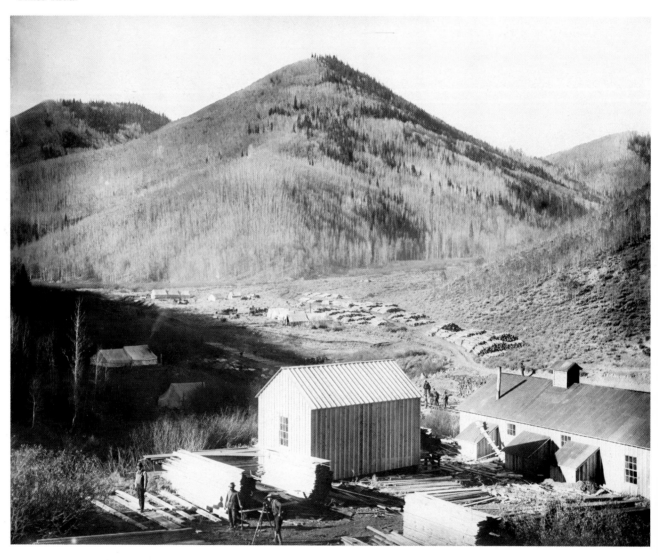

104. *Tucker and Thomas Sawmill, Clear Creek, Utah, ca. 1899. Lumber was easily accessible to the railroads and mining companies in this high alpine region with altitudes of over 8,000 feet. A workman is removing a railroad tie from the steam-powered saw.*

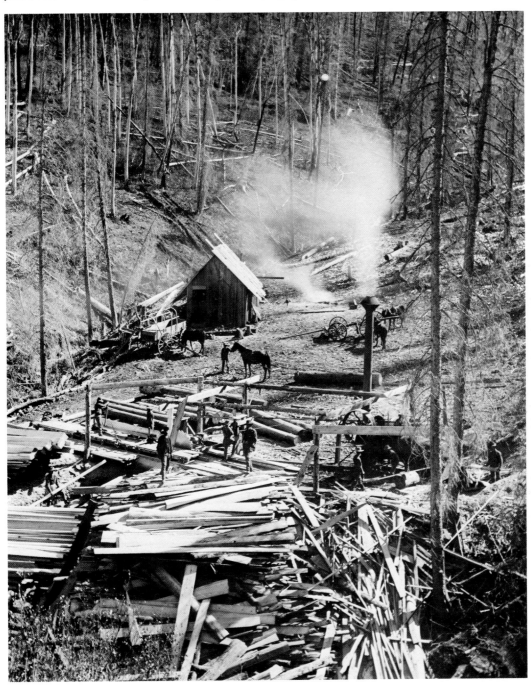

105. *Train Wreck on Coke Oven Tracks, Sunnyside, Utah, 1902. With a flair for the dramatic, Anderson photographed runaway coal cars that had toppled over the incline of the tracks at Sunnyside.*

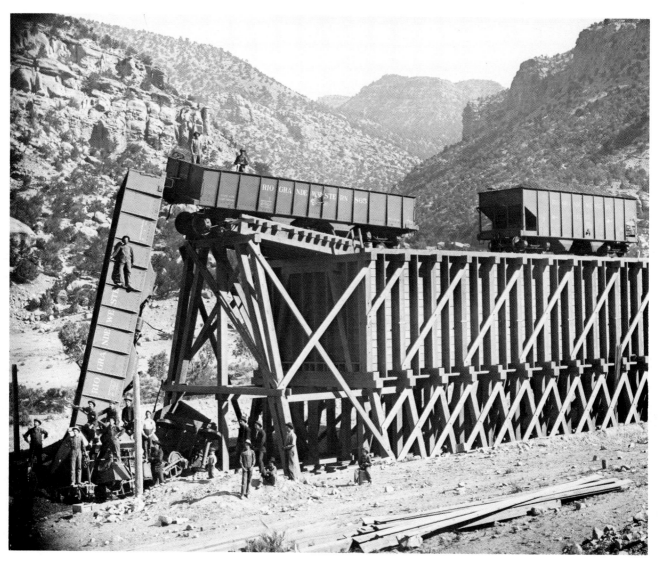

106. *Couple and Velocipede, Westwater, Utah, 1902. Whether by foot or by means of this hand-pumped vehicle, it is a long way to the nearest town from this remote railroad stop at Westwater, Utah, near the Colorado border. The railroad worker is identified only as "Mr. Johnson." Another photograph shows the woman sitting behind him—apparently she decided to ride.*

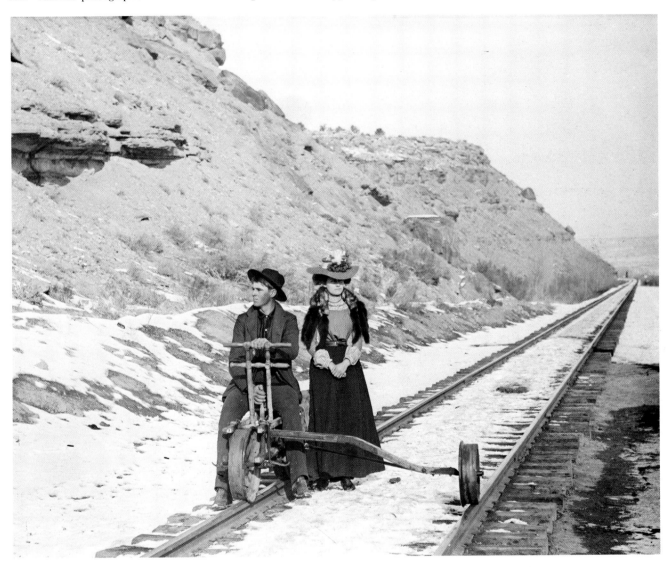

107. *Construction of Coke Ovens at Sunnyside, Utah, 1902. Eventually more than eight hundred of these beehive coke ovens were in operation at Sunnyside.*

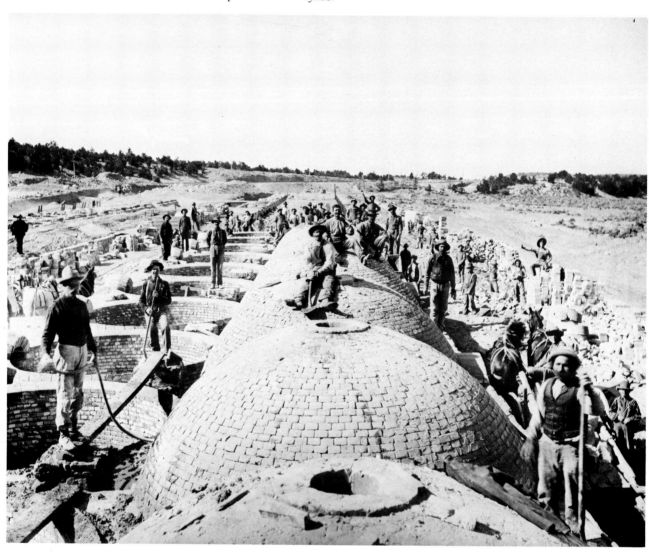

108. *Main Street of Springville, 1900. The afternoon sun lights the Wasatch Mountains and Anderson's hometown. In 1900, Springville had a population of about 3,000; the Central School in the background and the Springville Bank (with the cupola, at right) were built in 1892.*

109. *Saltair Beach and Pavilion, Salt Lake City, Utah, 1902. Perhaps the most popular Utah resort was Saltair, where even the poorest swimmer could not sink in the heavy salt water. In the 1960s the old pavilion, built in 1893, burned completely.*

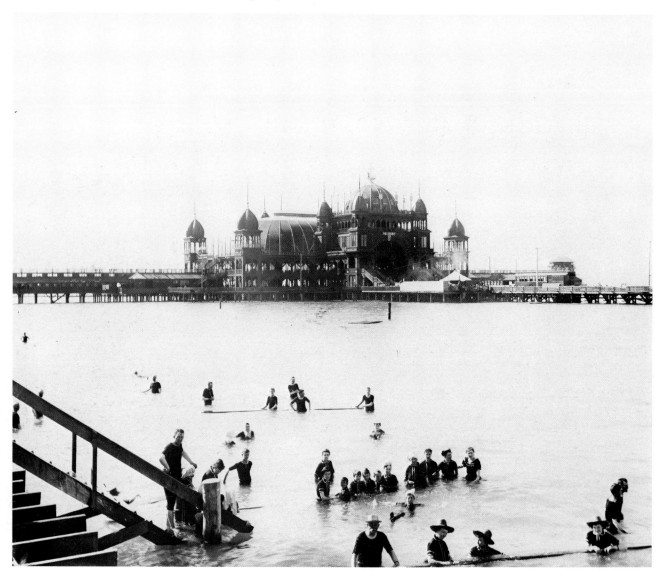

110. *Railroad Surveyors, Modena, Utah, 1904. Anderson's railroad pictures include surveyors for the San Pedro, Los Angeles, and Salt Lake Railroad companies, who planned western expansion into southern California to compete with the Union Pacific and the Oregon Short Line Railroads.*

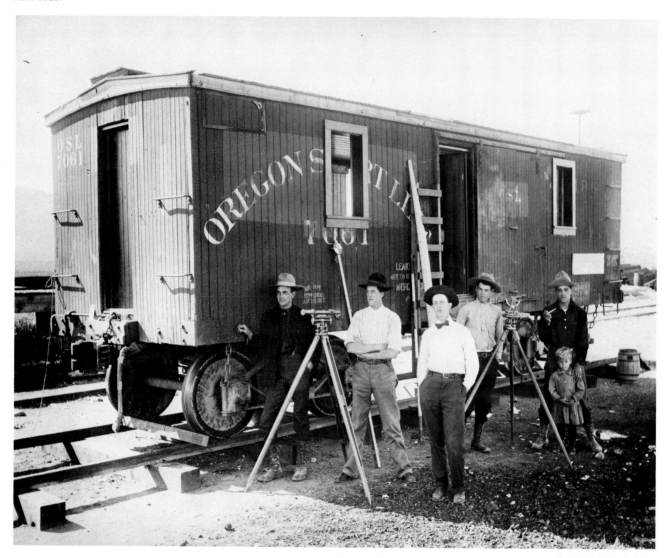

111. *Hyrum Clyde Onion Crop, Springville, Utah, 1906. The Utah Exhibit at the San Francisco World's Fair in 1939 showed this print of Anderson's to demonstrate Utah's agricultural productivity. The picture had been taken more than a quarter of a century earlier and demonstrates Utah's other bumper crop—its children. George Dewey Clyde, front, third from left, was Governor of Utah, 1957–65.*

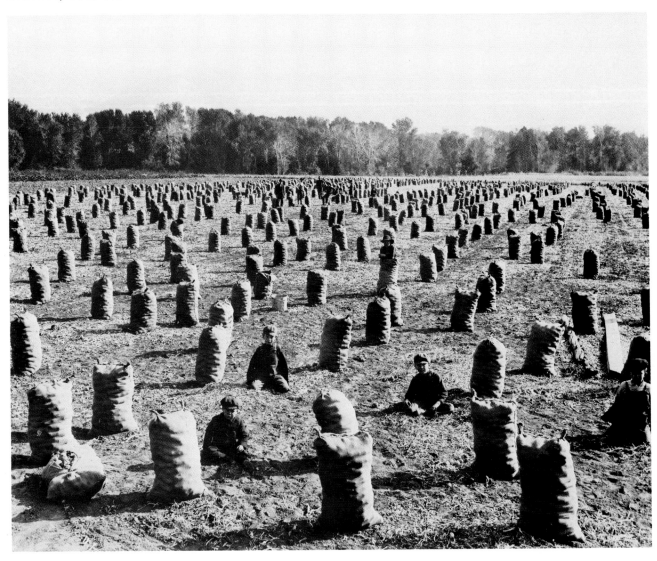

112. *Railroad Steam Shovel, Mapleton, Utah, 1914.* In 1914 the Utah Railway built a track adjacent to the Denver and Rio Grande between Provo and Thistle, Utah, to provide two-way travel to benefit both companies. The steam shovel is loading flatcars near Spanish Fork Canyon to carry gravel for the new roadbed.

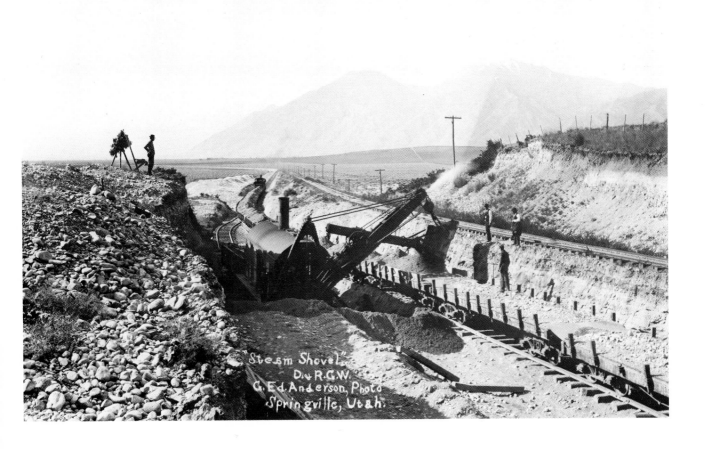

113. *Interior of Anderson's Studio, Springville, Utah, ca. 1914. Anderson who is wearing the hat and his assistant, Ralph Snelson, are shown in the upstairs studio with its overhead skylight, Victorian backdrop, view camera, reflectors, and other props. The studio was torn down in the early 1950s for his son's automobile business.*

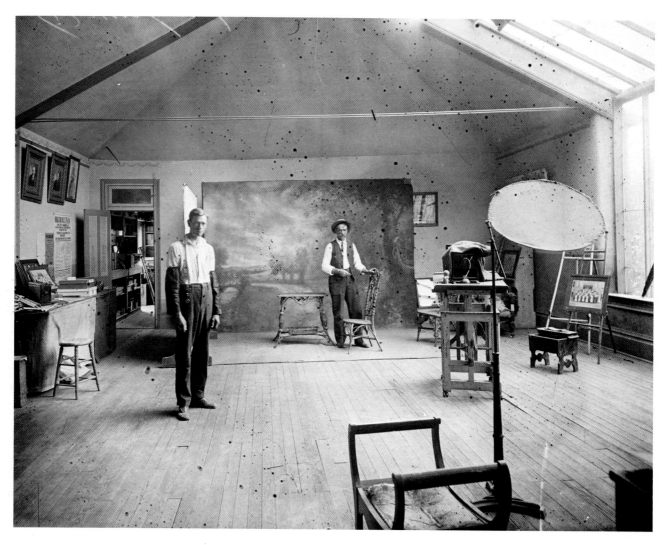

114. *Erecting Power Line Poles for Interurban Train, Springville, Utah, 1915.* Telephone poles were removed from the center of Main Street at Springville, and poles to support the power lines for the new electric interurban railway were erected on each side of the road. These men were working directly in front of Anderson's studio.

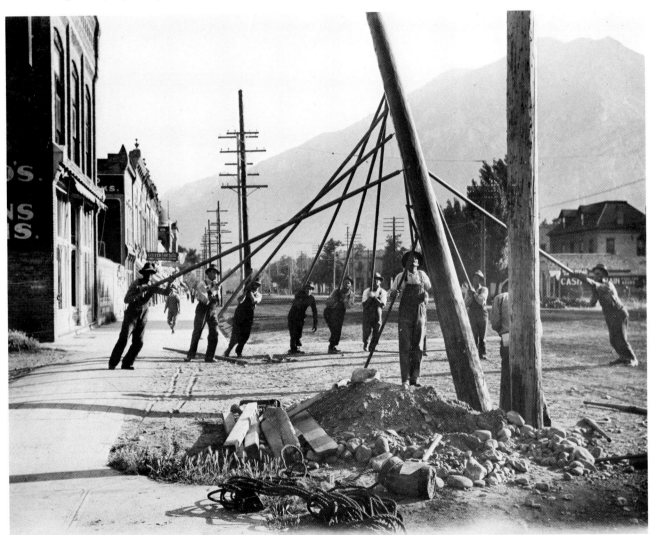

115. *T. T. Maroney and Airplane, Payson, Utah, 1916. The featured attraction of the grand celebration to commemorate the completion of the Strawberry Irrigation Project and the inter-urban train to Payson, Utah, on May 27, 1916, was the spectacular flight of T. T. Maroney in his Curtiss Headless, pusher-type airplane.*

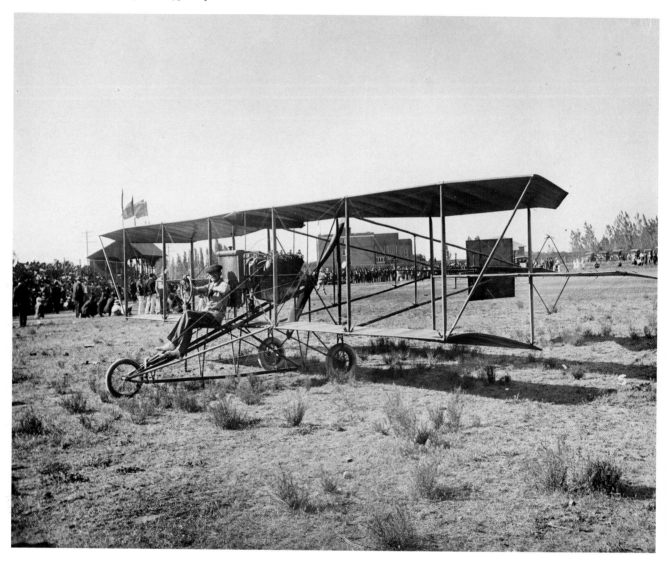

116. *Sanpete County Fair, Manti, Utah, 1926. Forty years after Anderson took his first pictures of the Manti Temple, he returned to this site to document a horse-powered carnival ride at the Sanpete County Fair.*

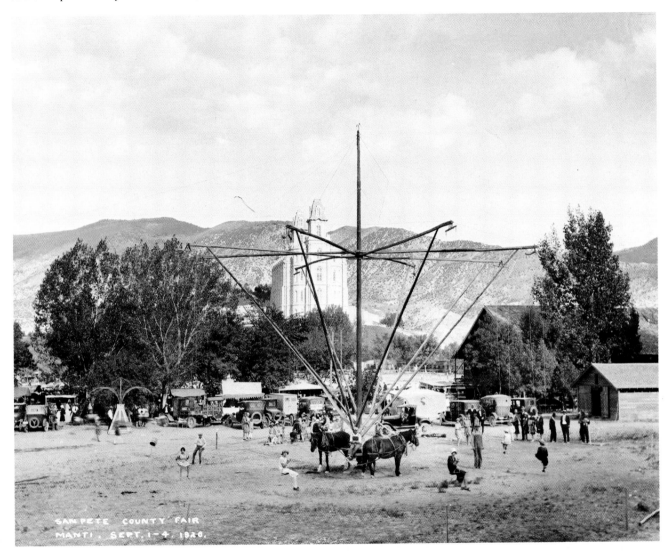

Index